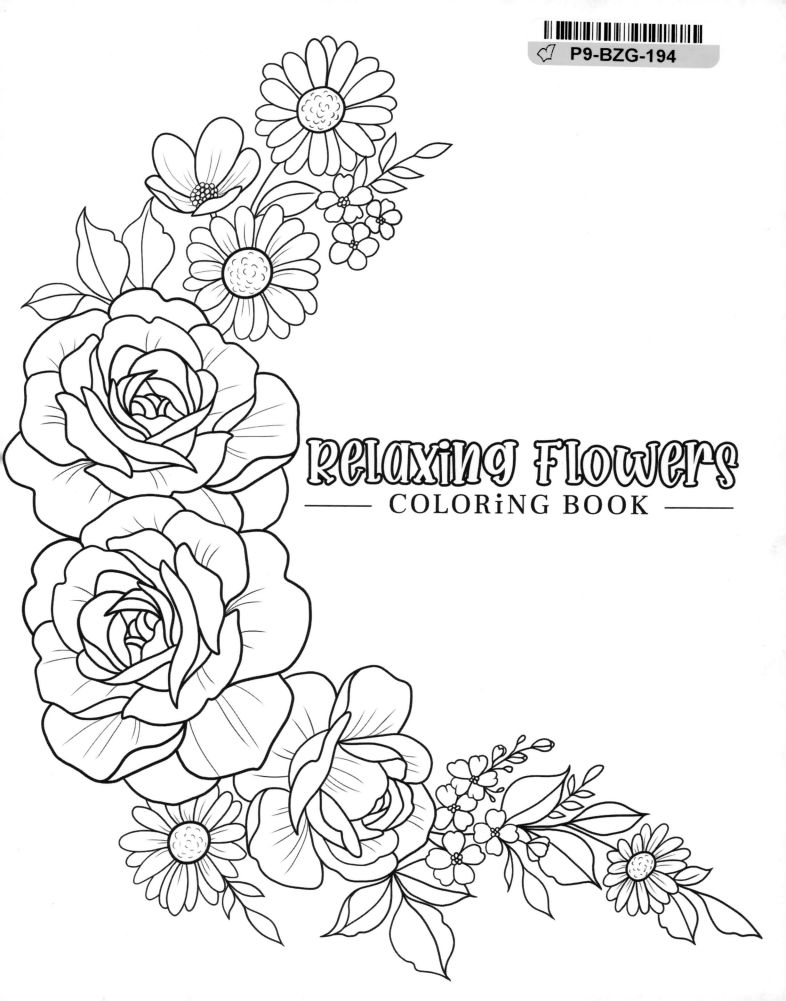

Relaxing Flowers
— COLORiNG BOOK —

Relaxing Flowers: Coloring Book For Adults With Flower Patterns, Bouquets, Wreaths, Swirls, Decorations.

ISBN: 9798566353050

For more informations and to stay updated on new coloring books visit our web site at www.coloringbookkim.com

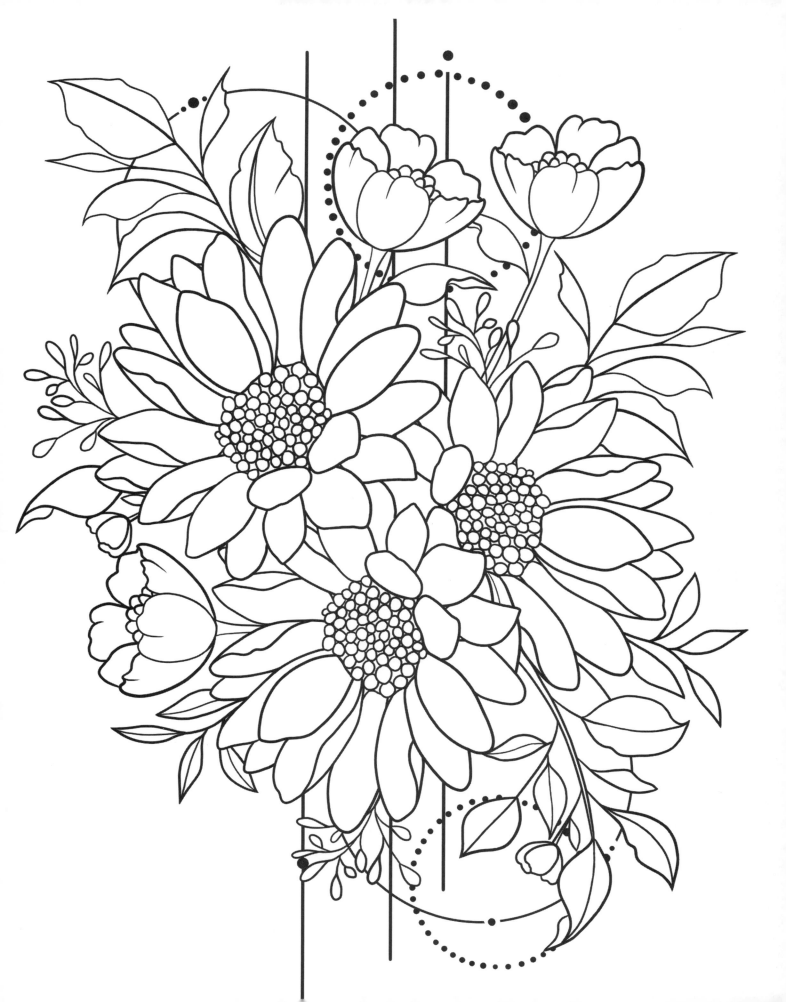

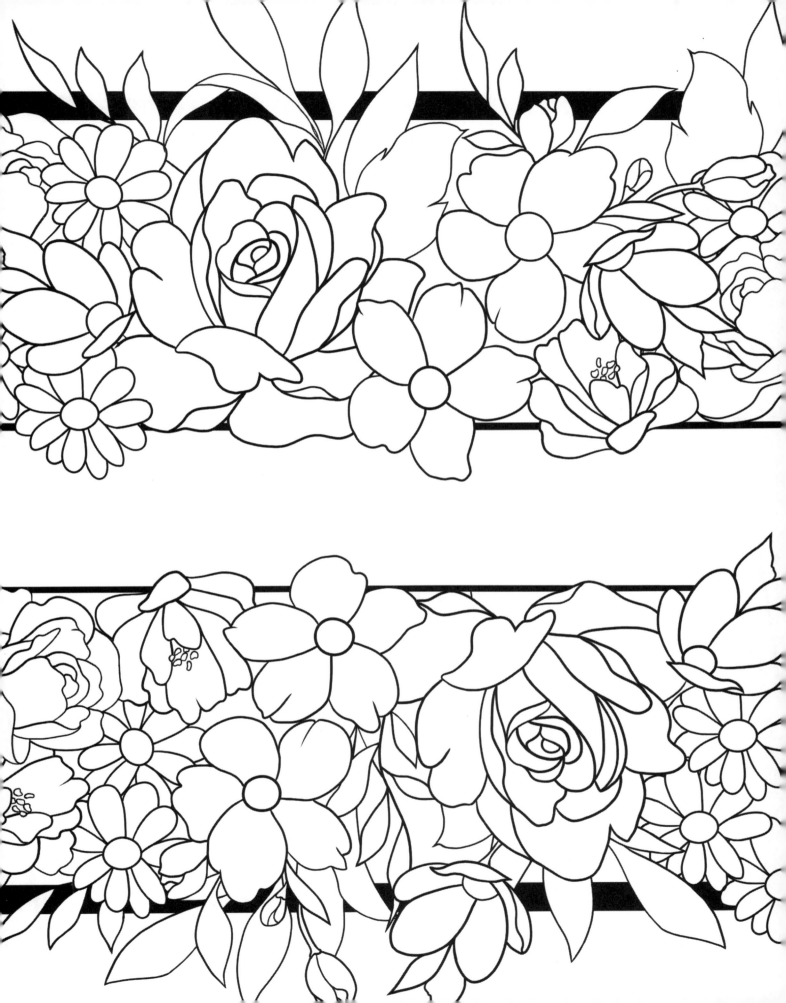

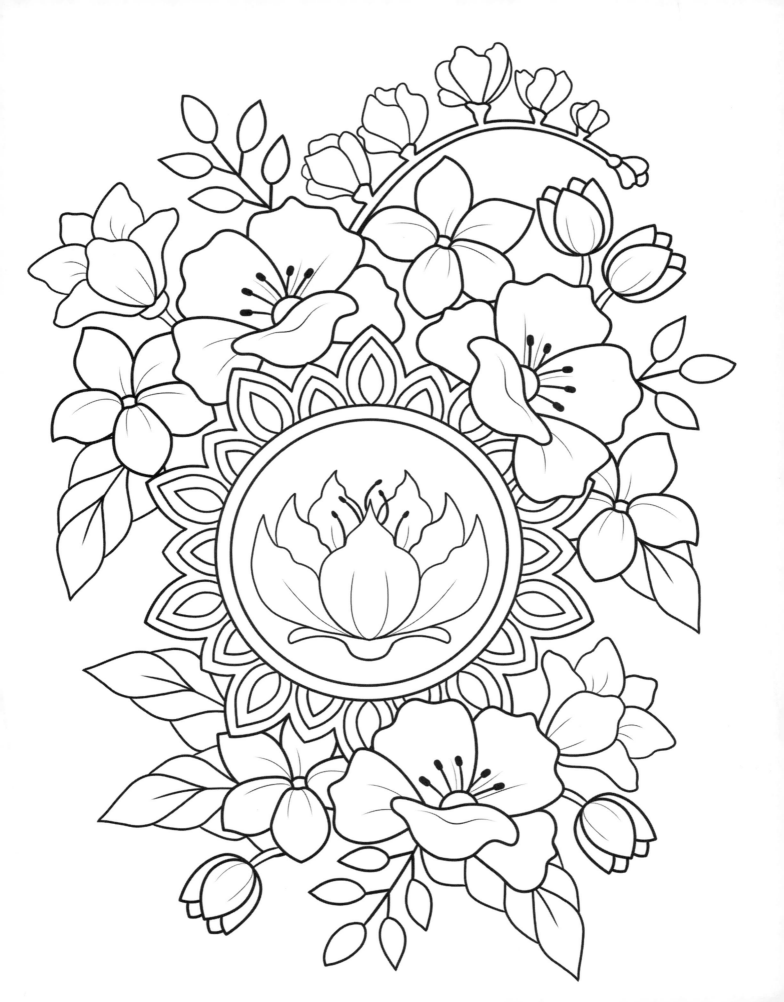

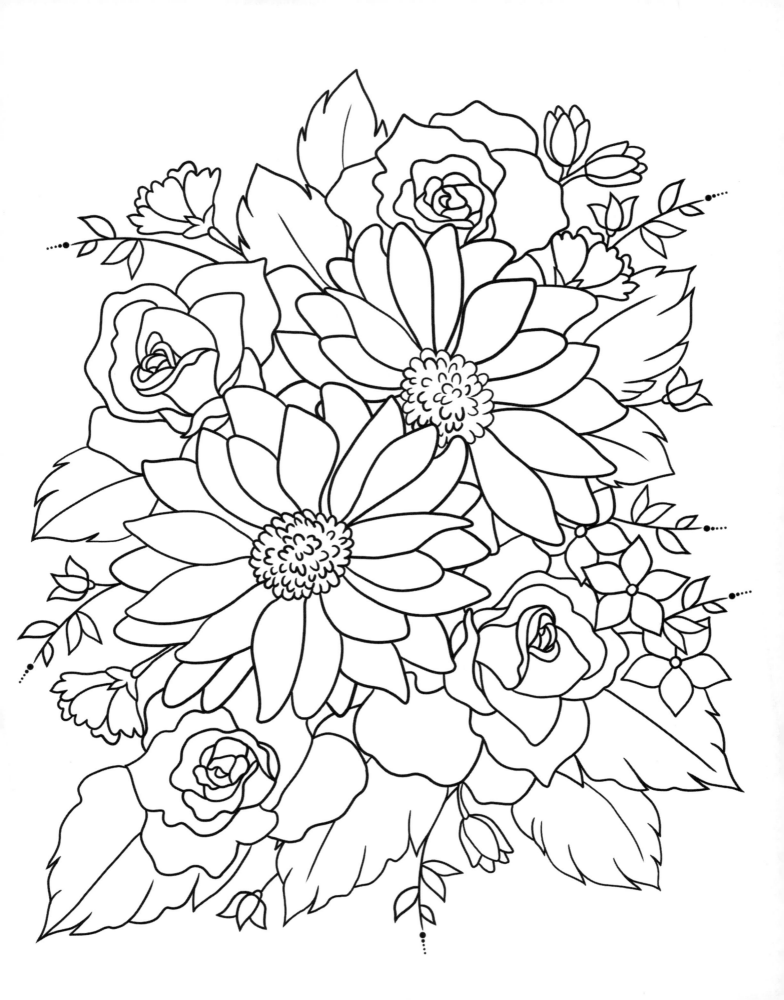

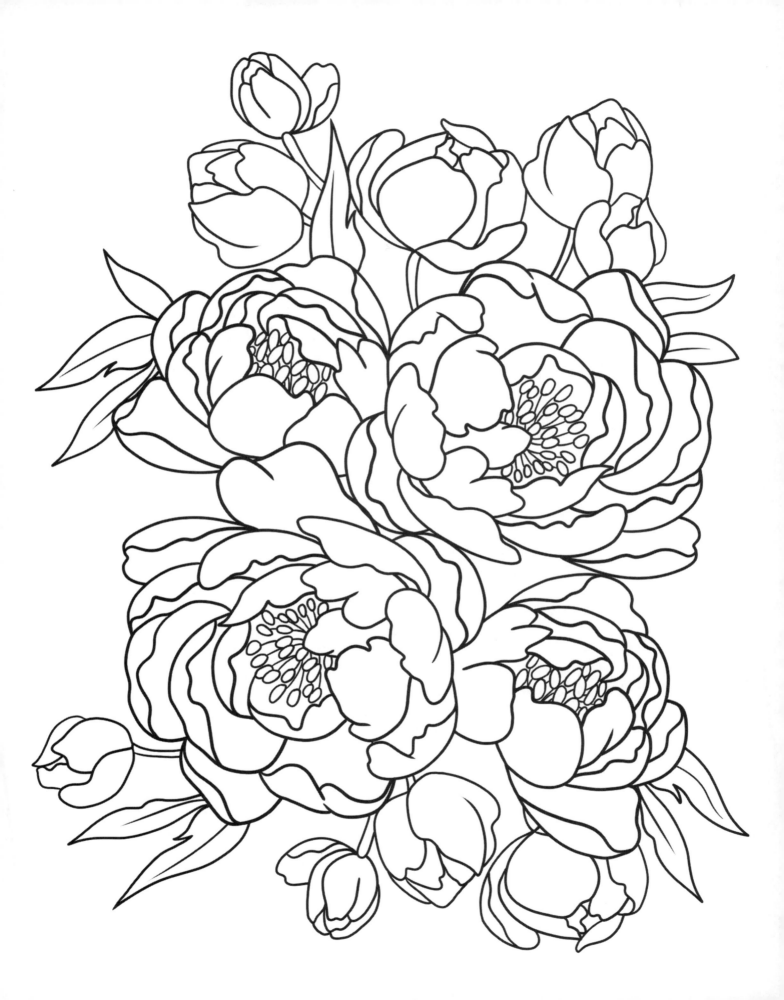

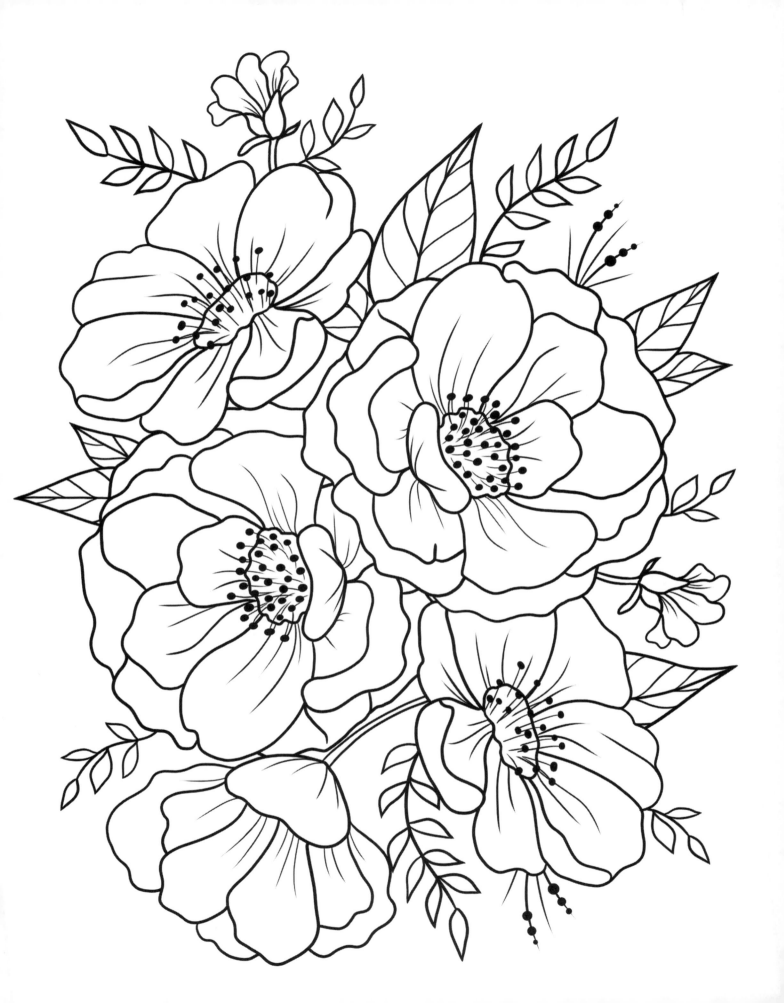

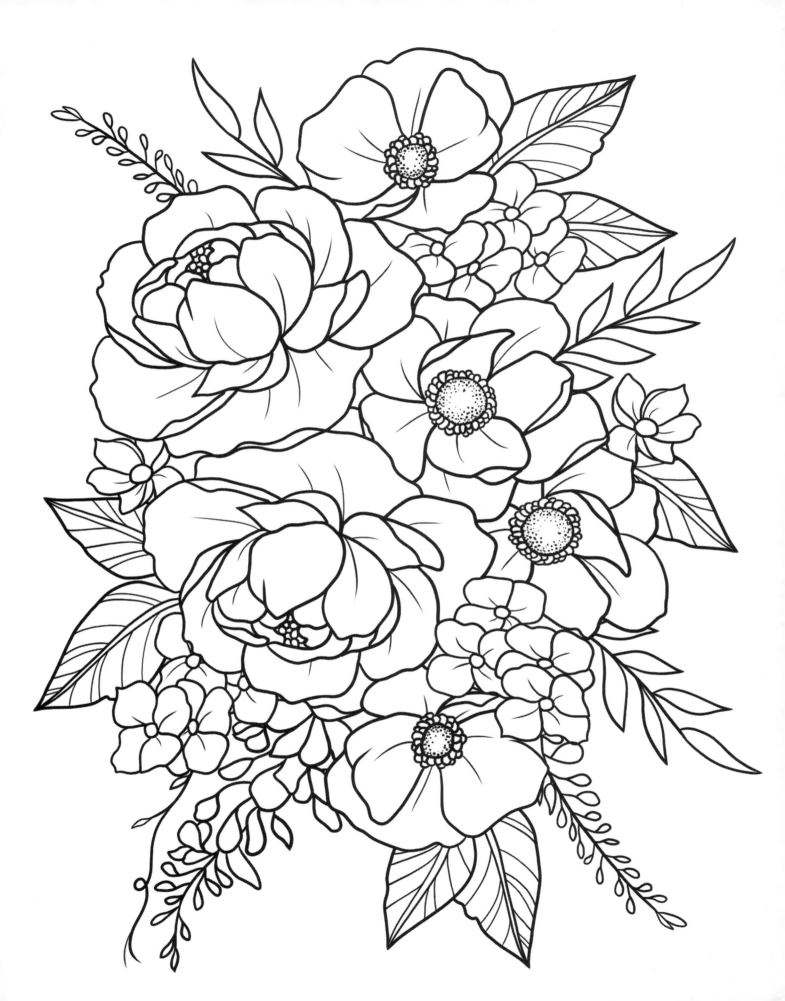

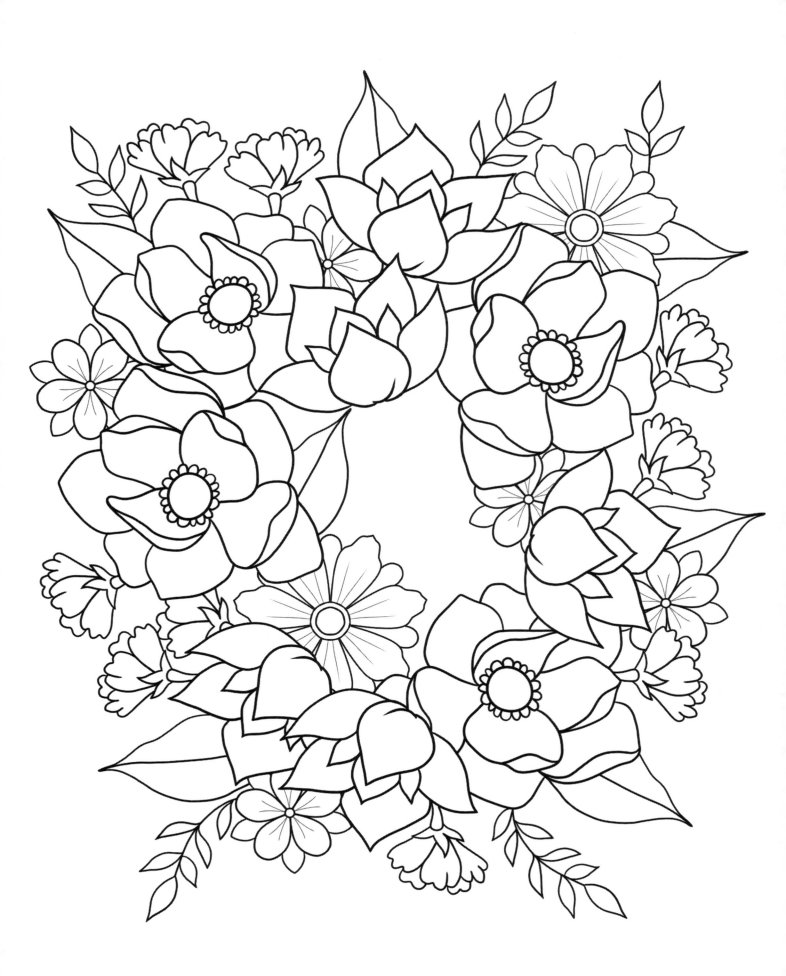

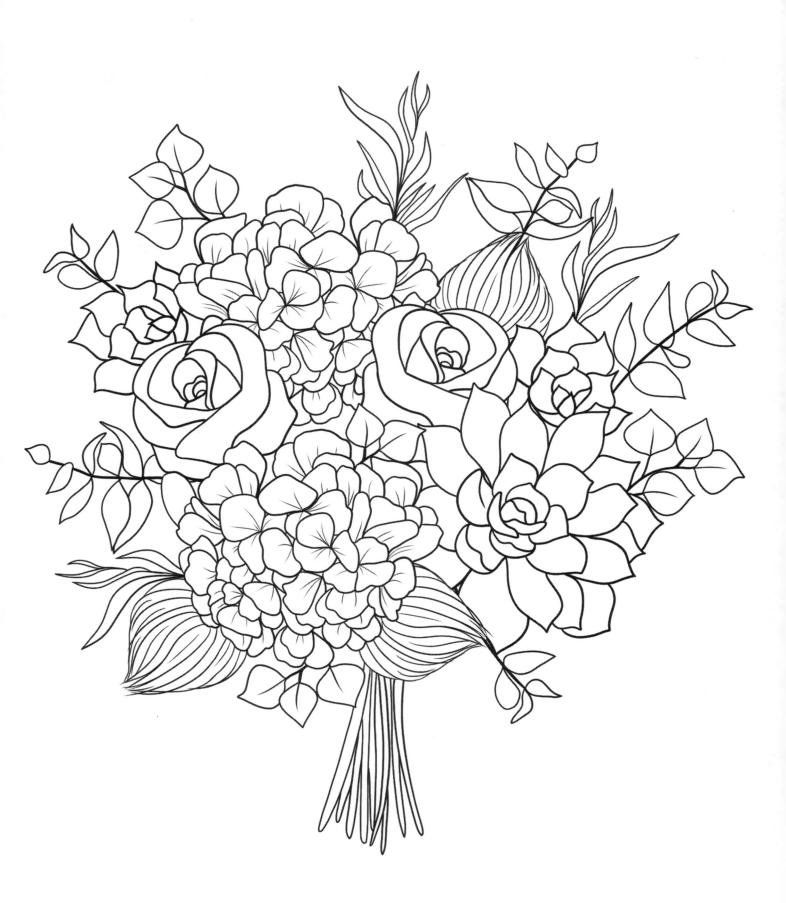

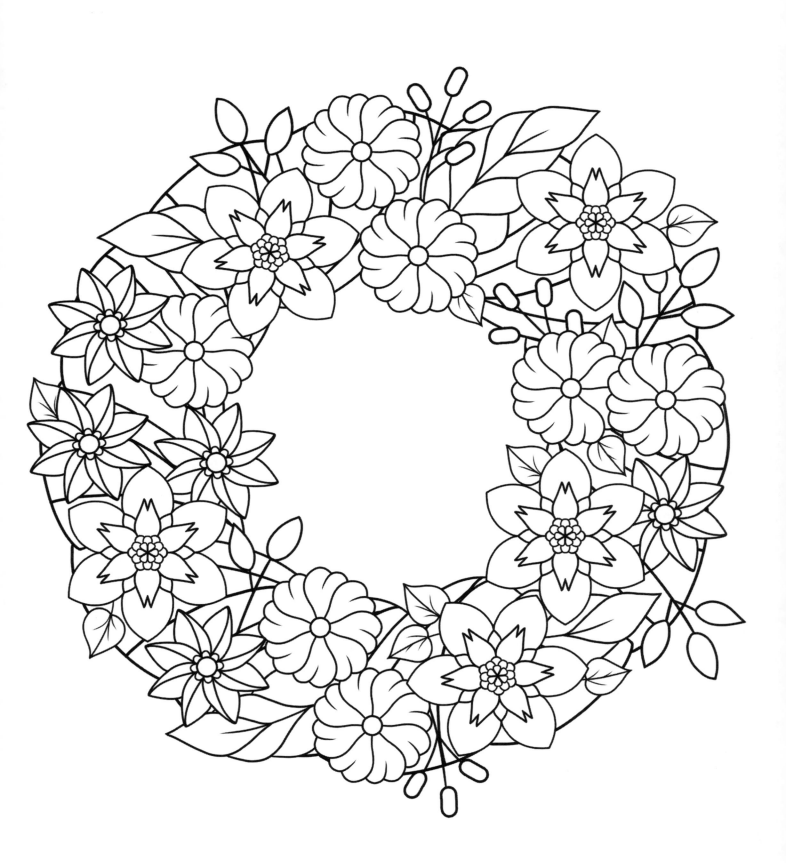

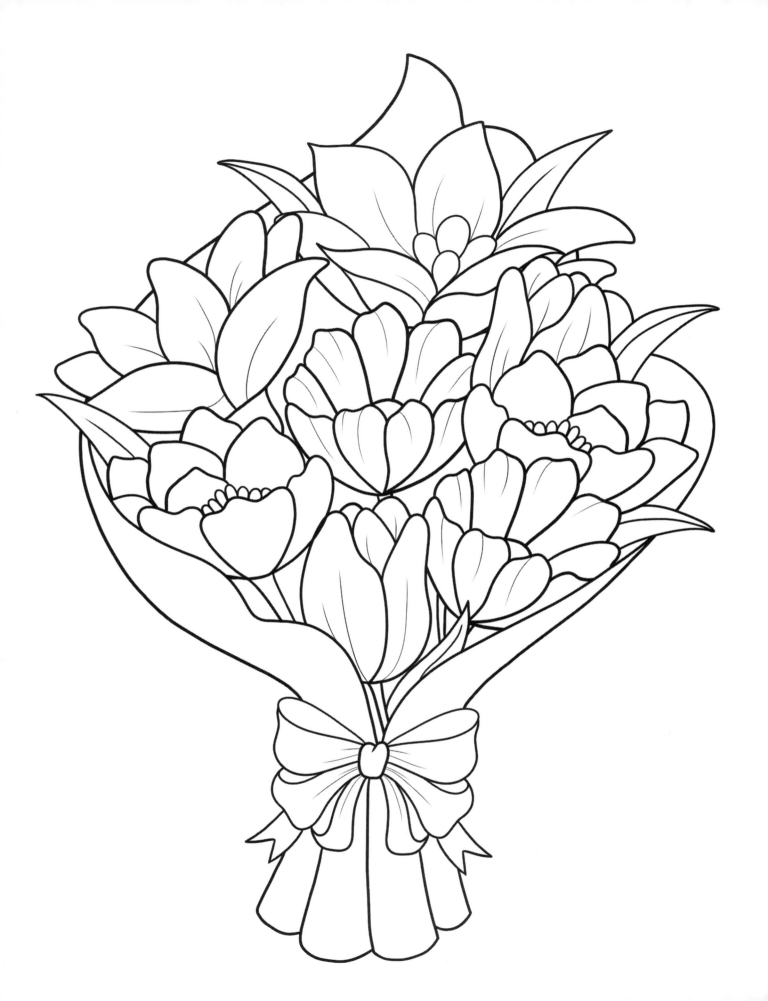

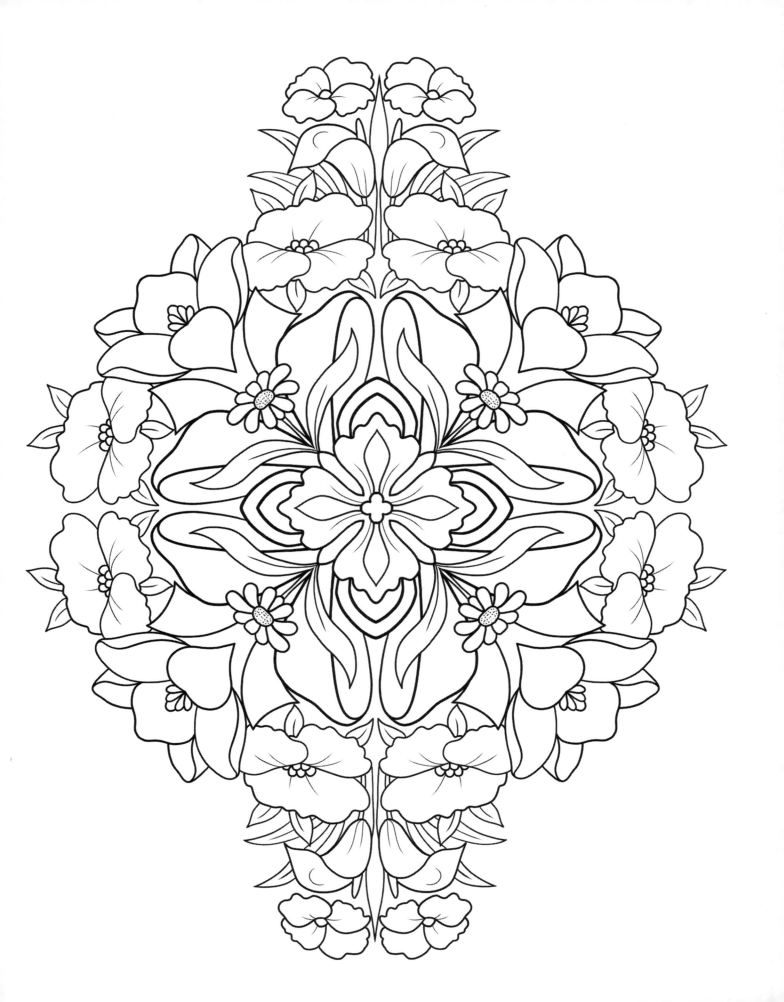

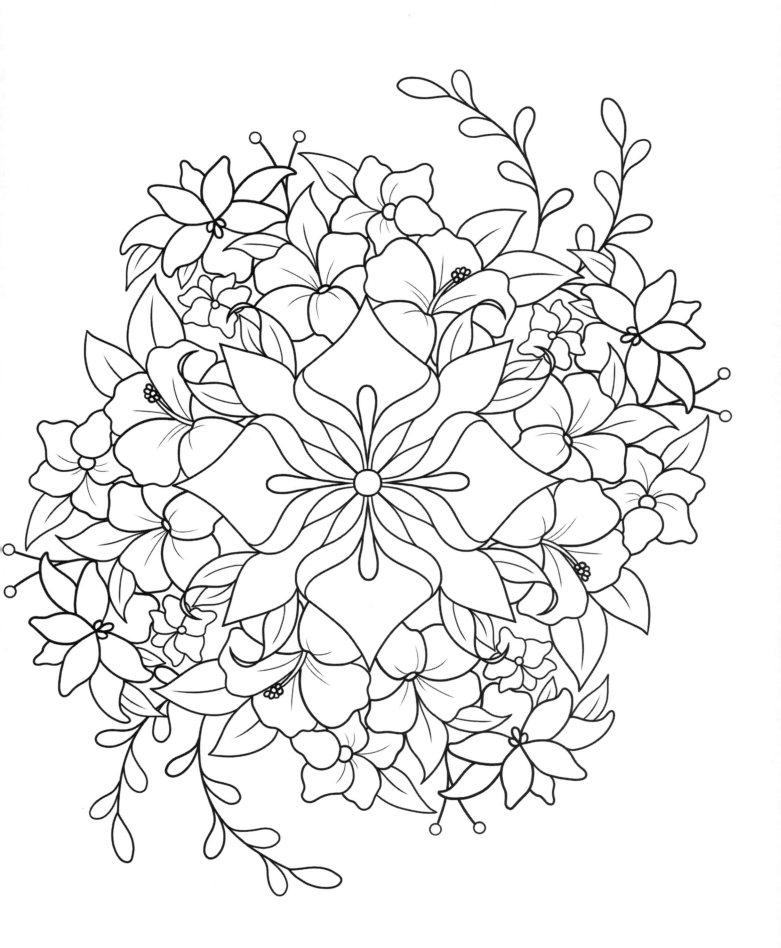

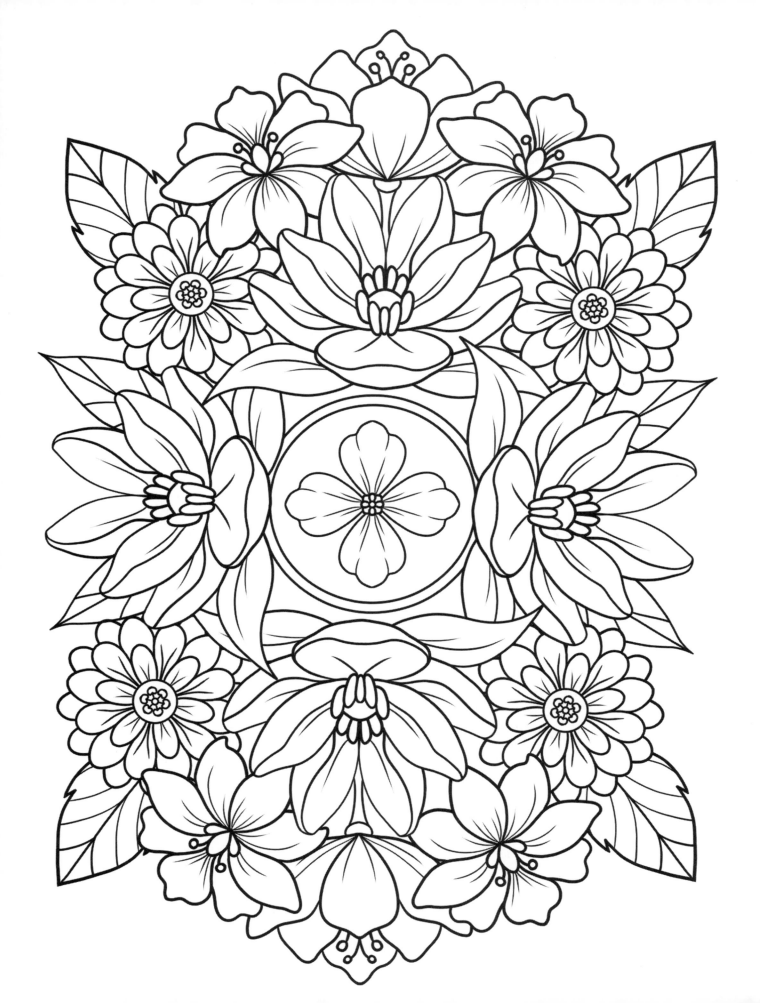

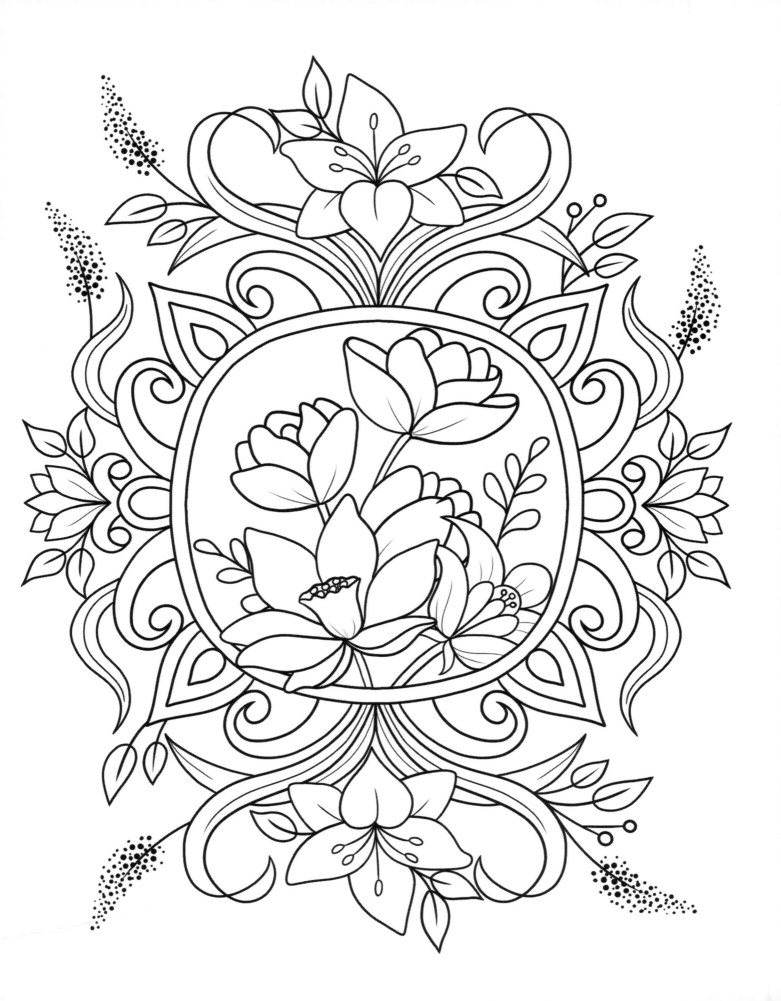

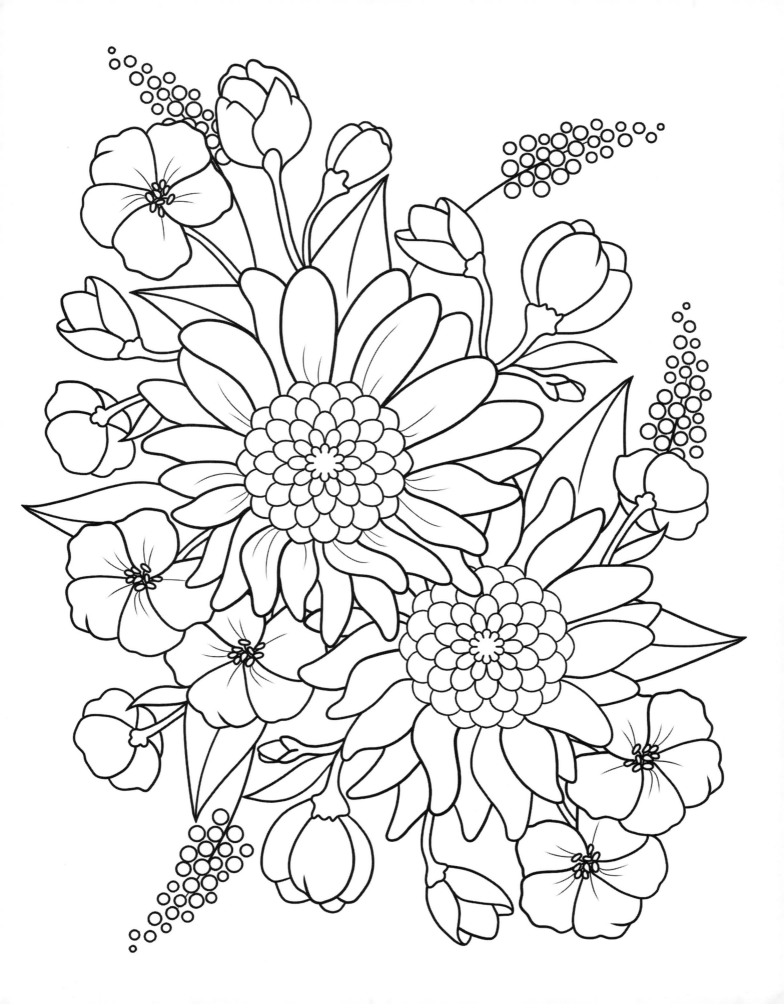

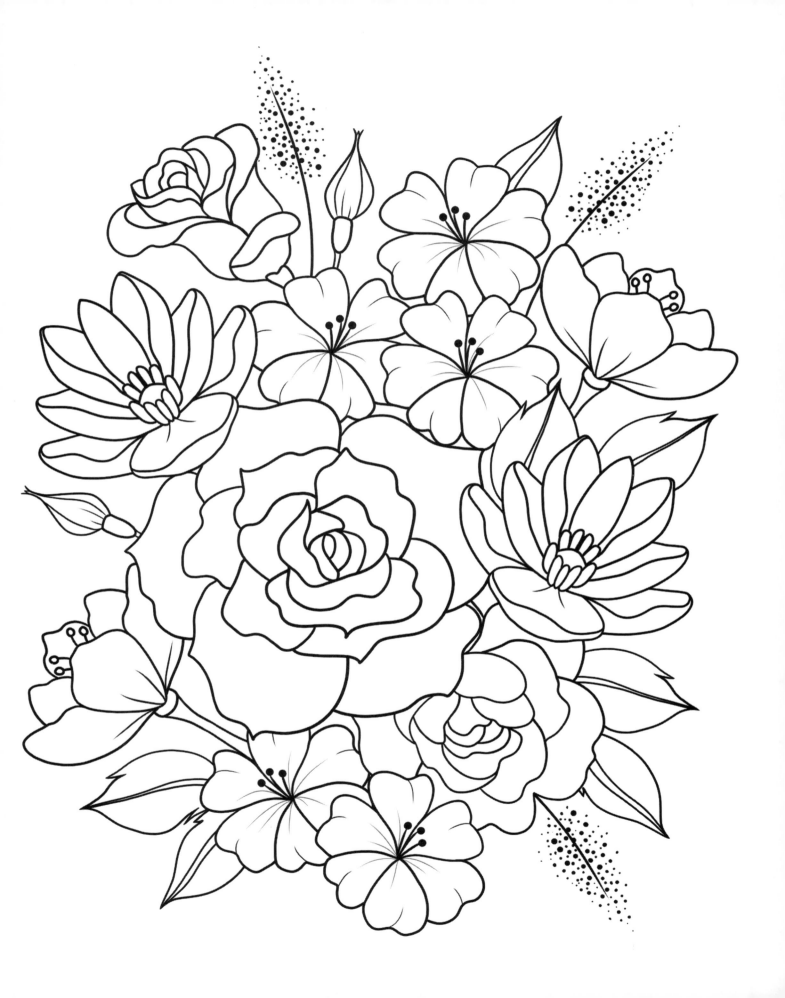

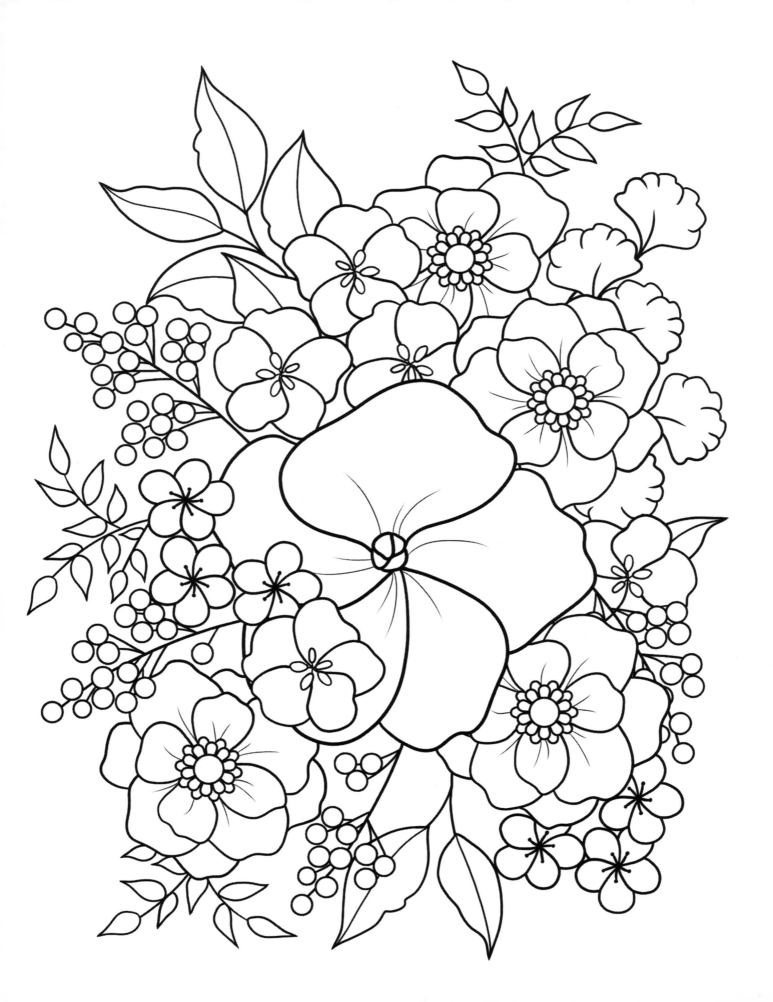

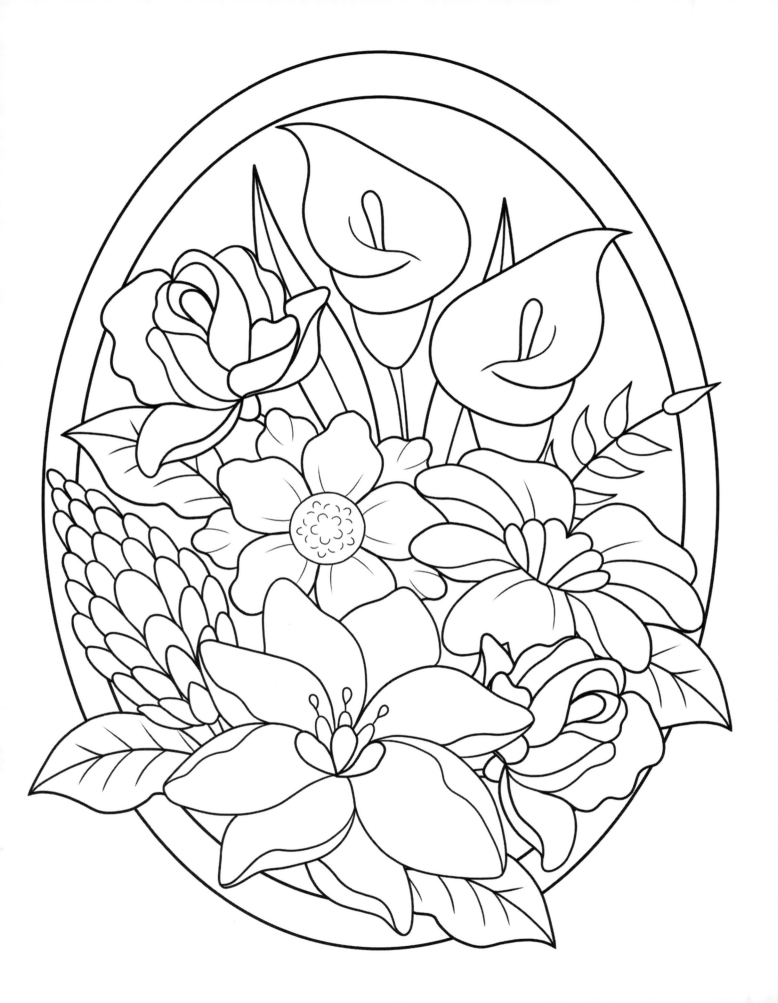

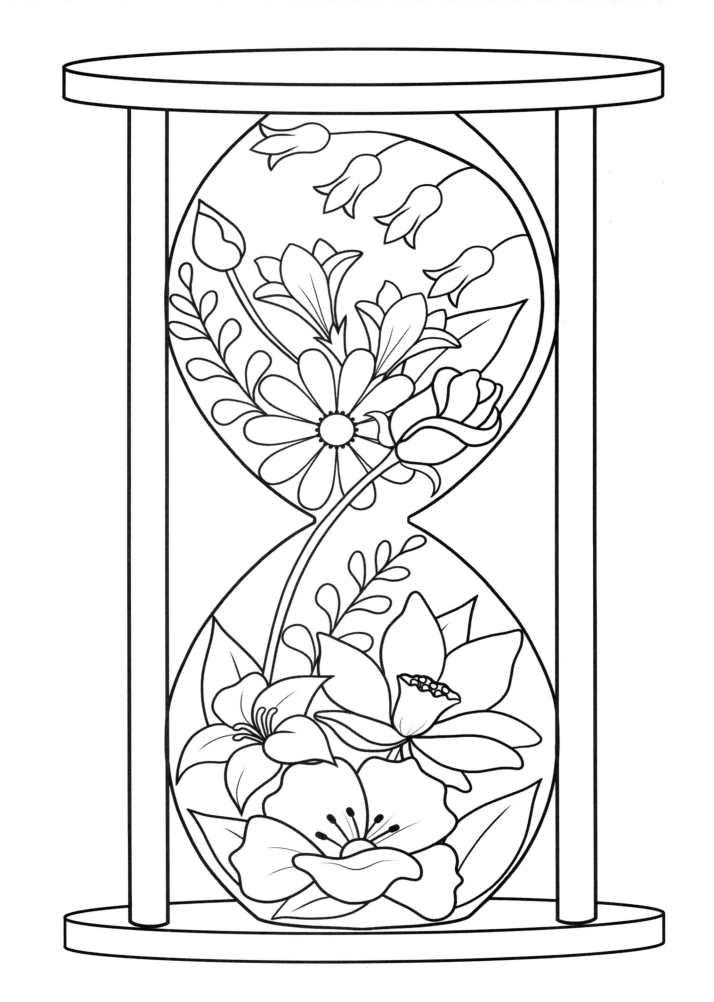

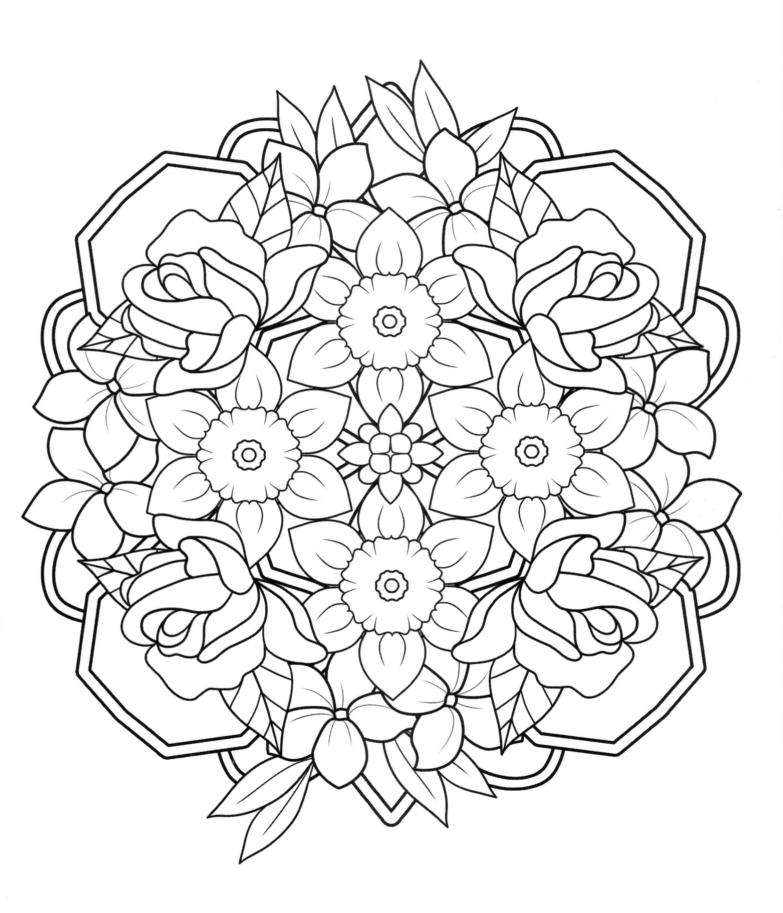

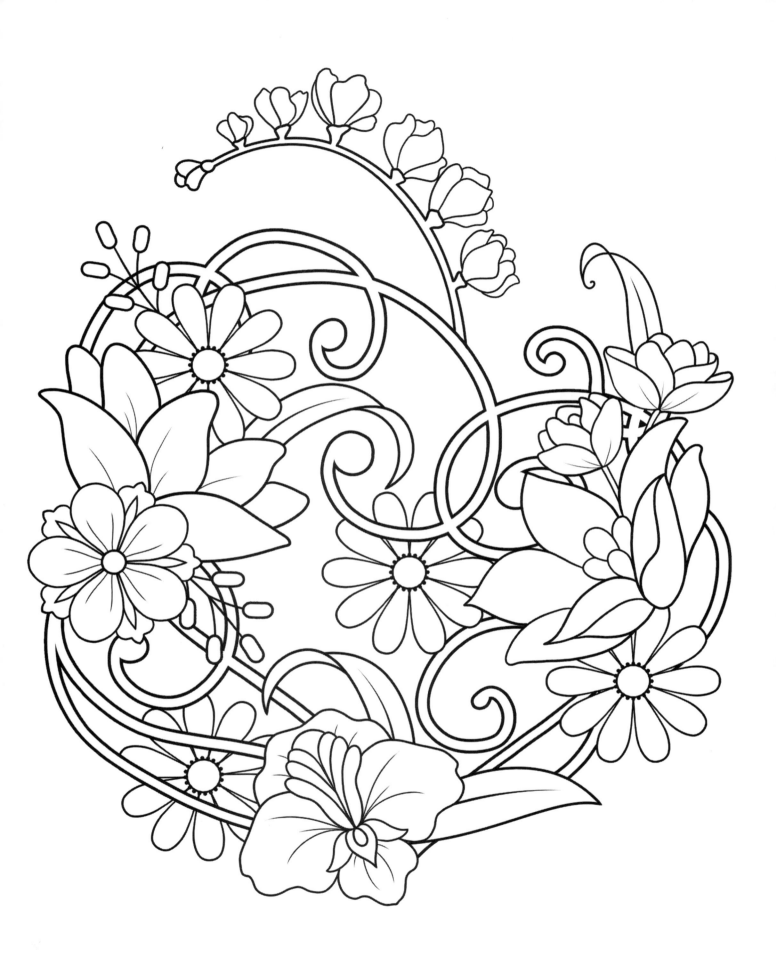

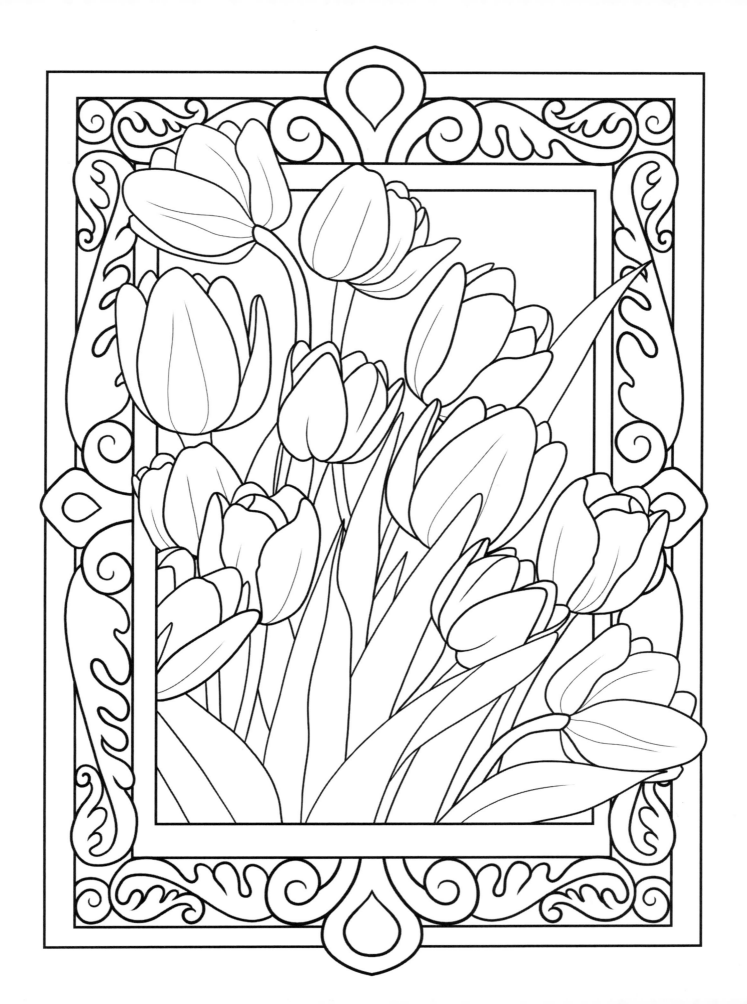

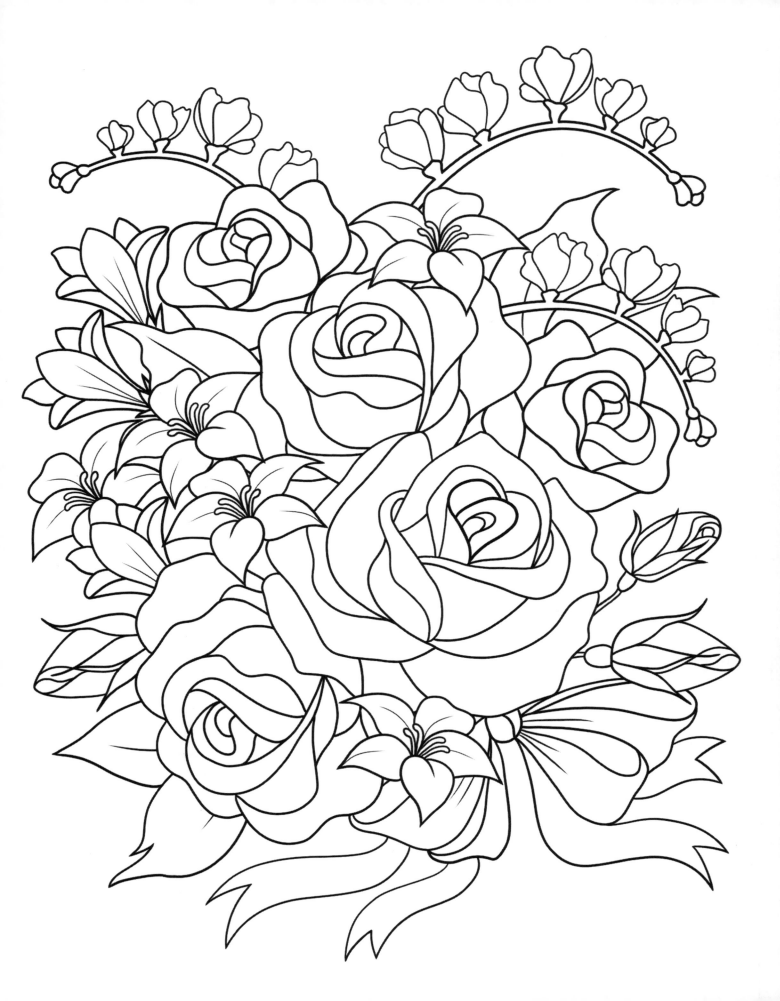

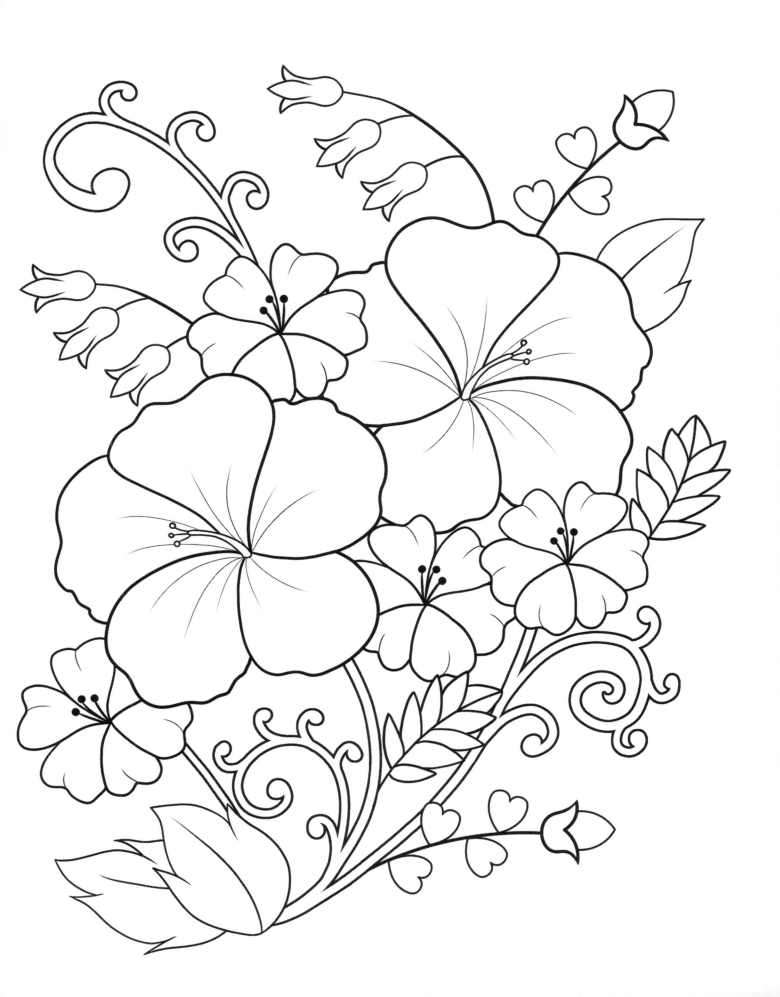

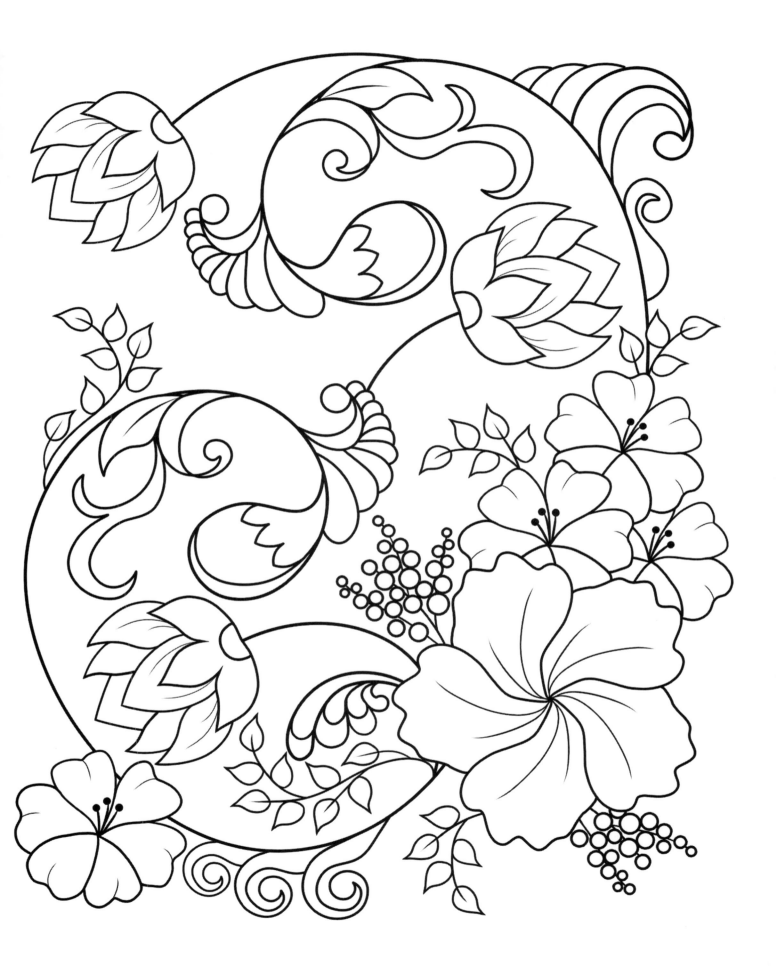

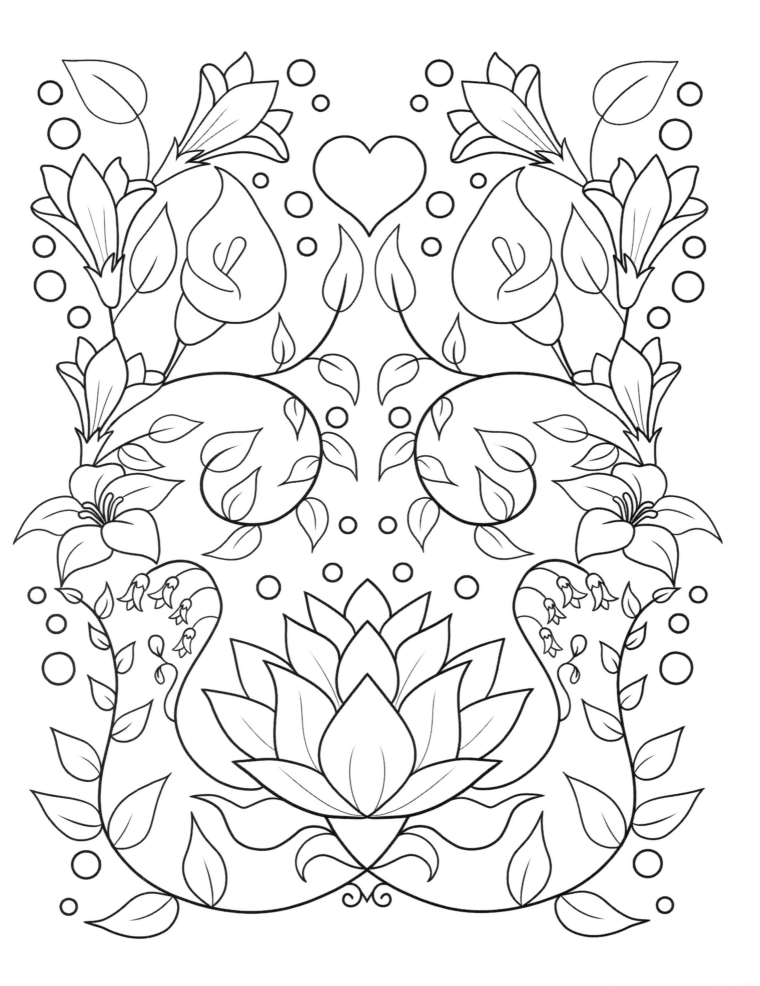

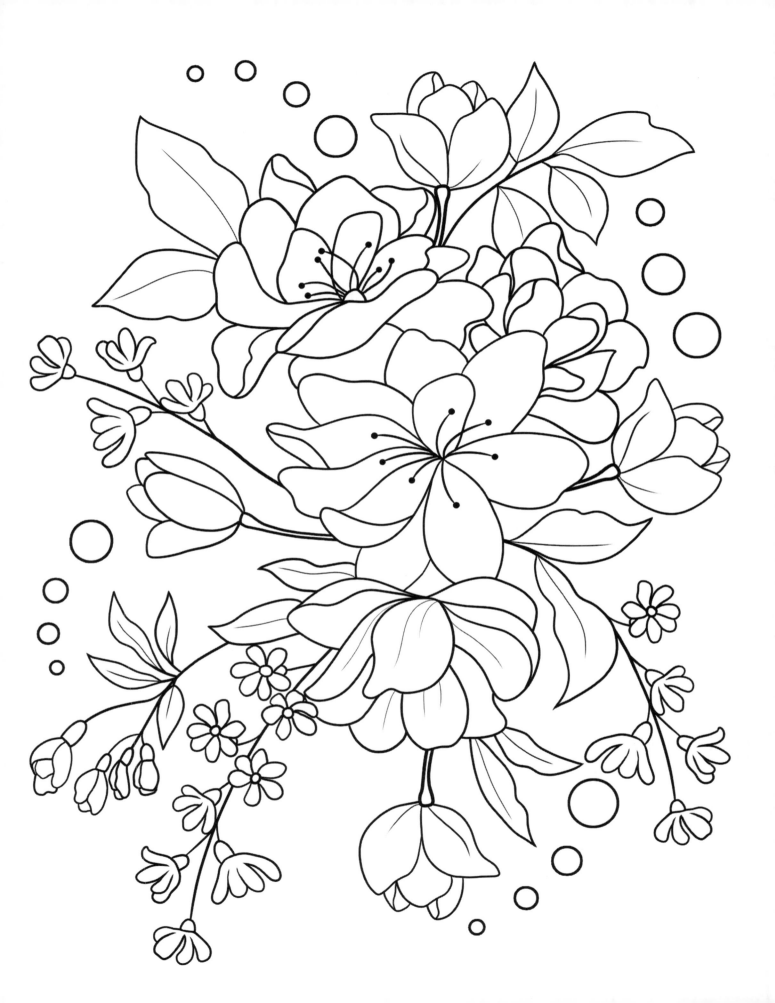

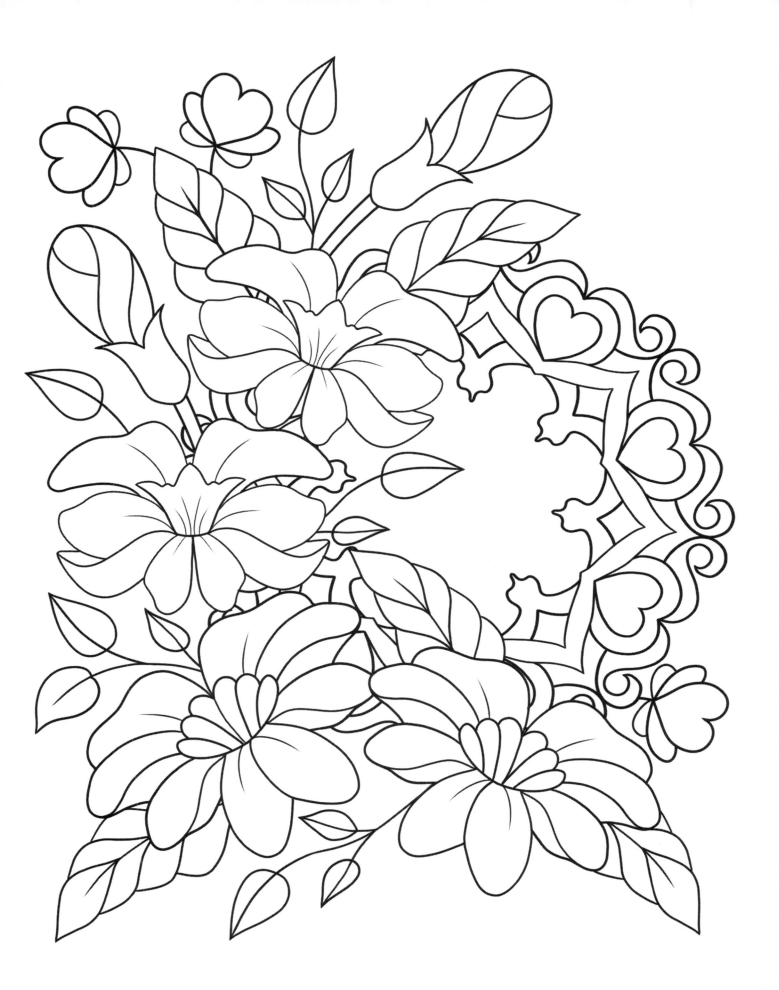

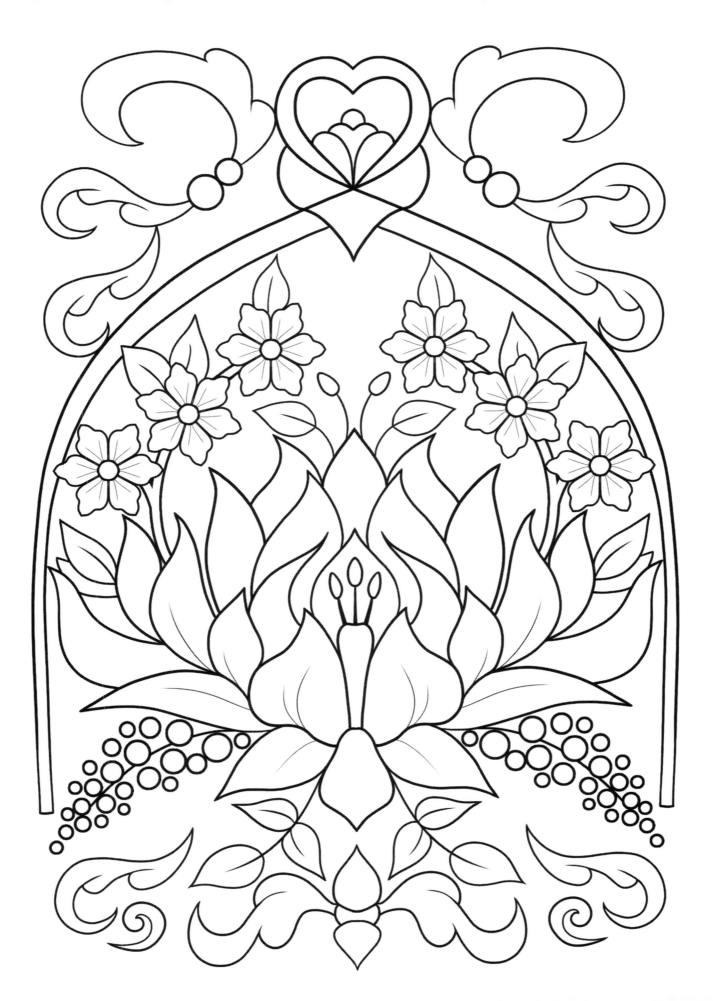

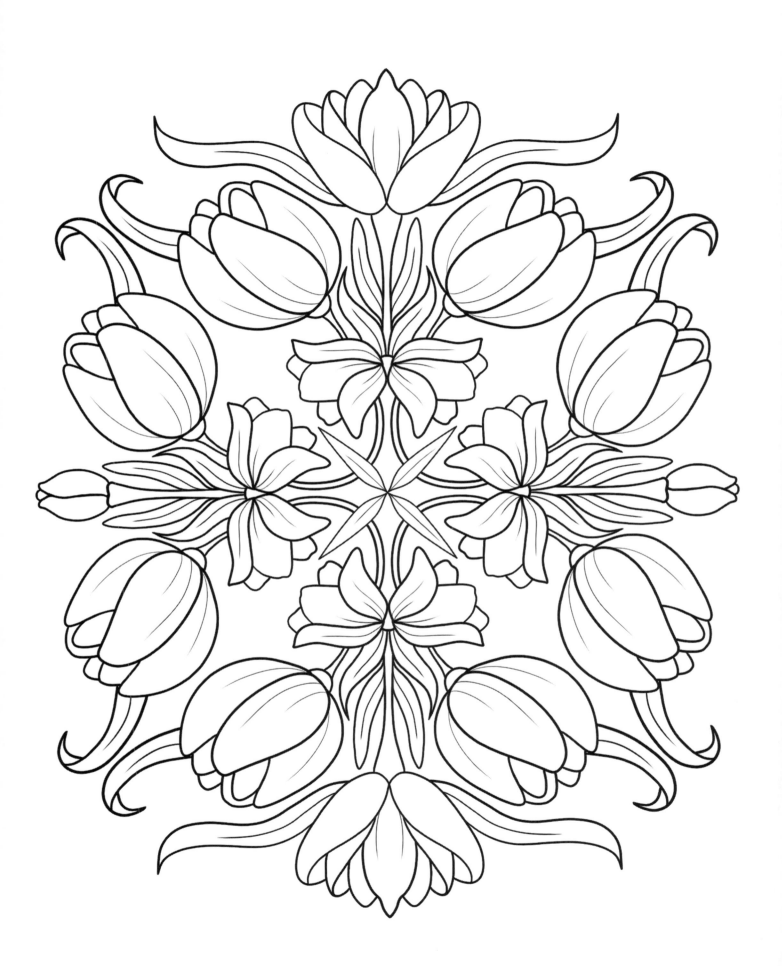

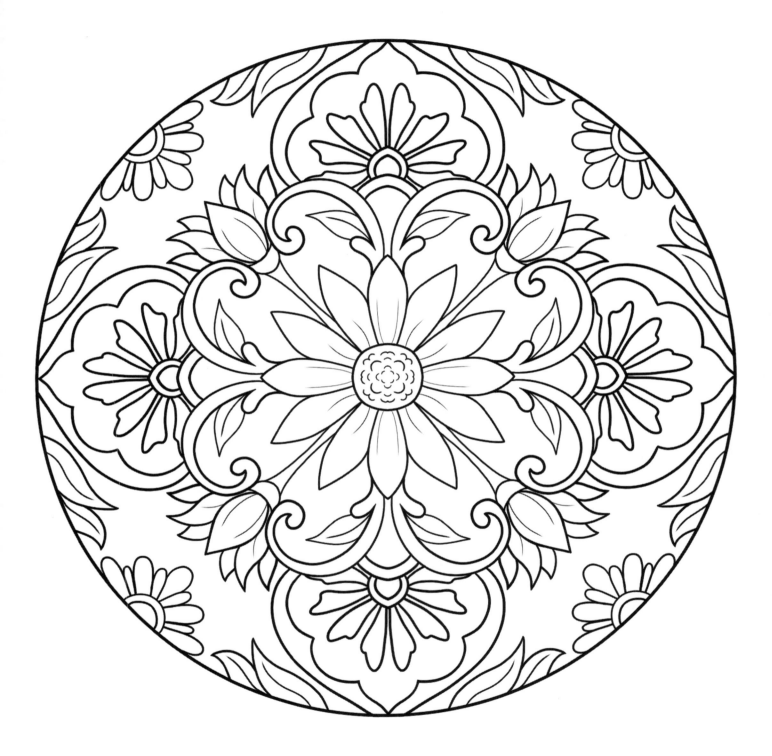

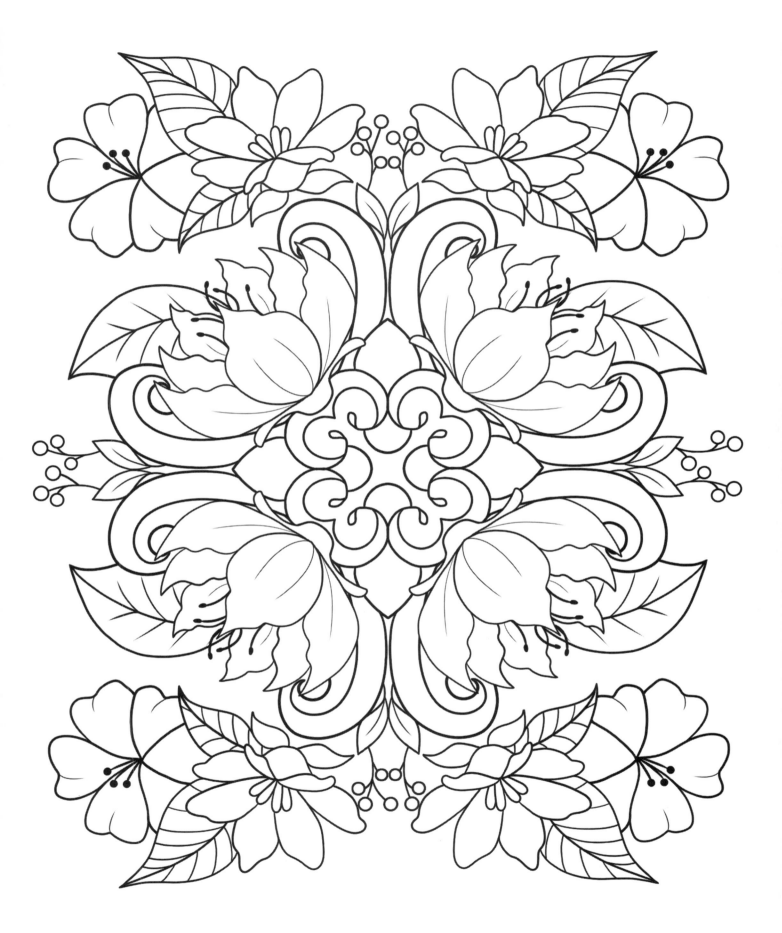

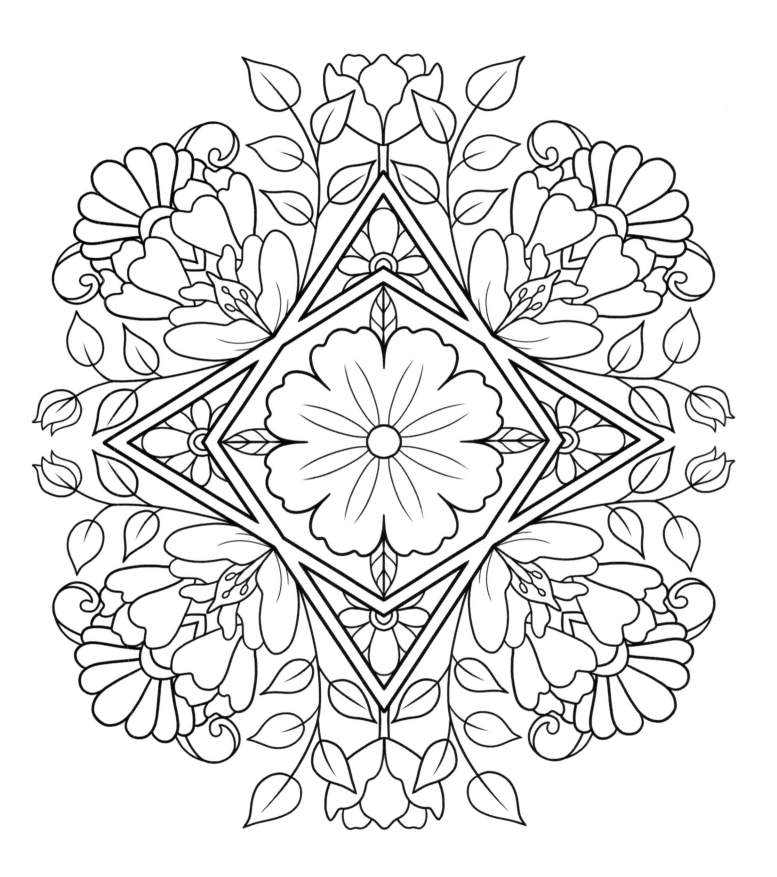

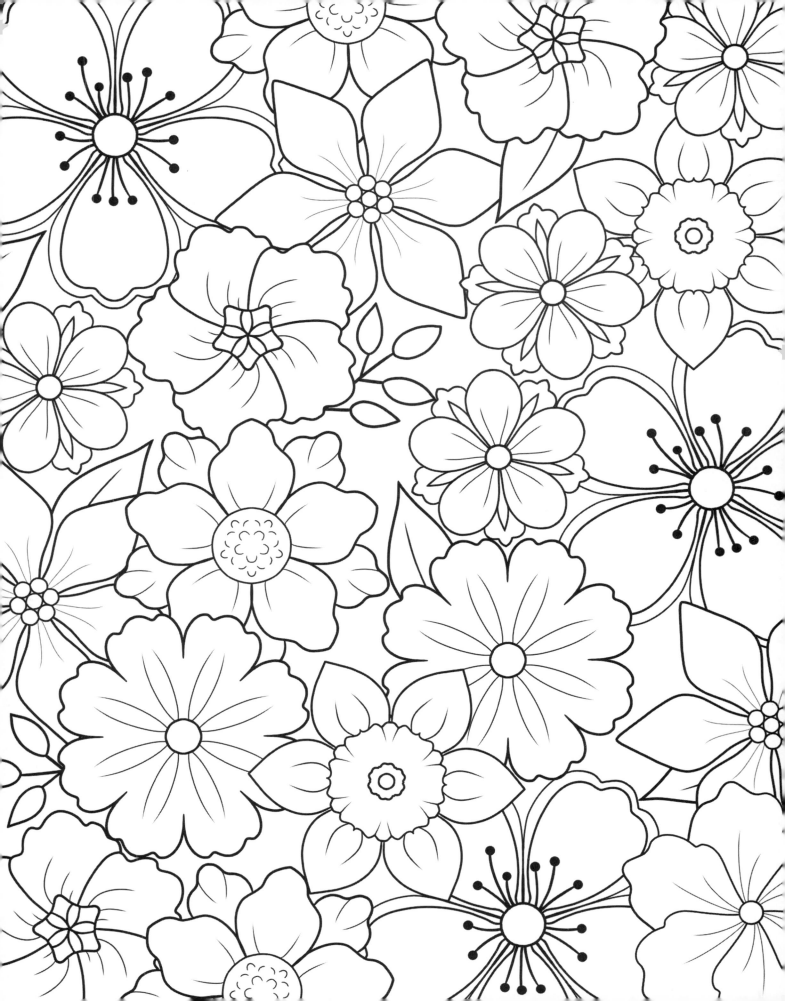

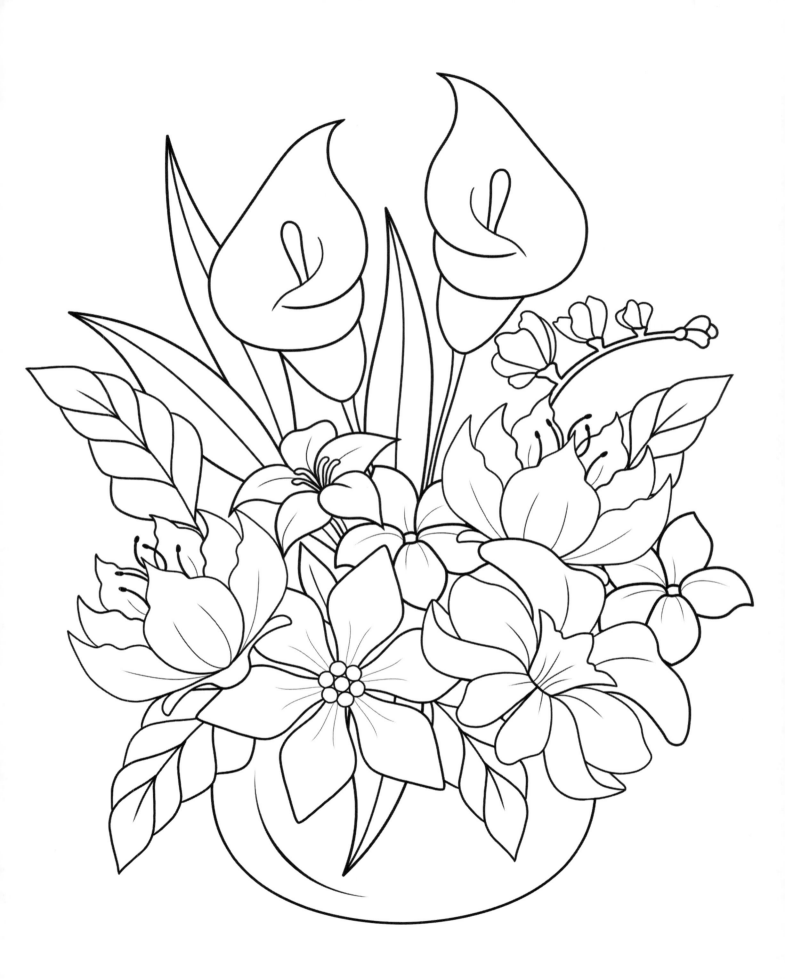

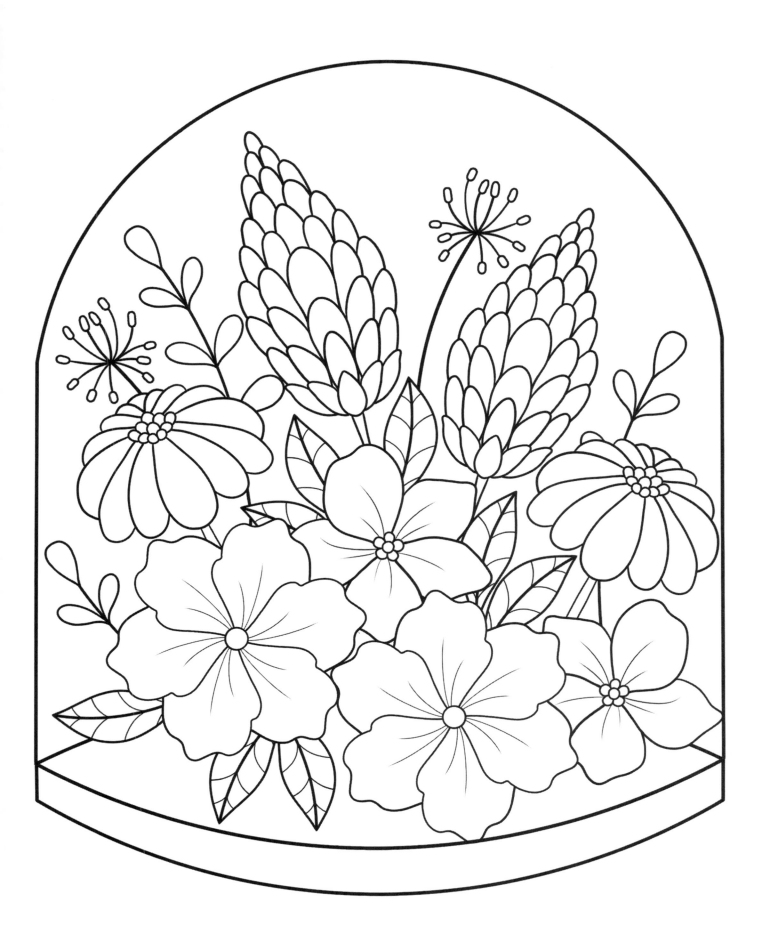

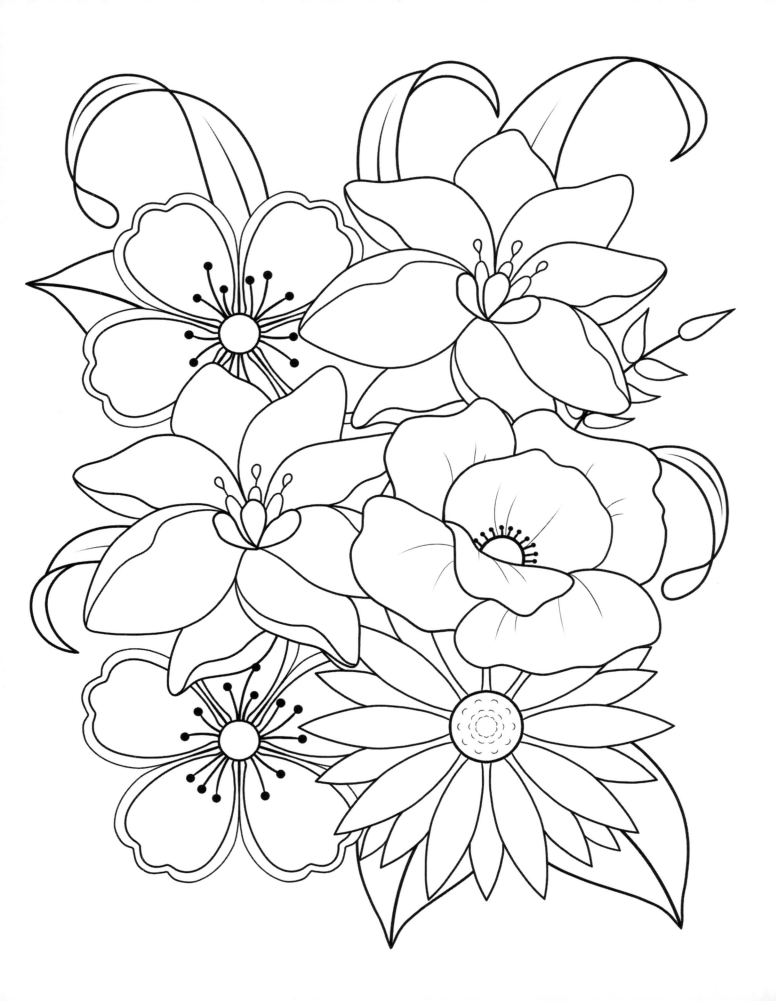

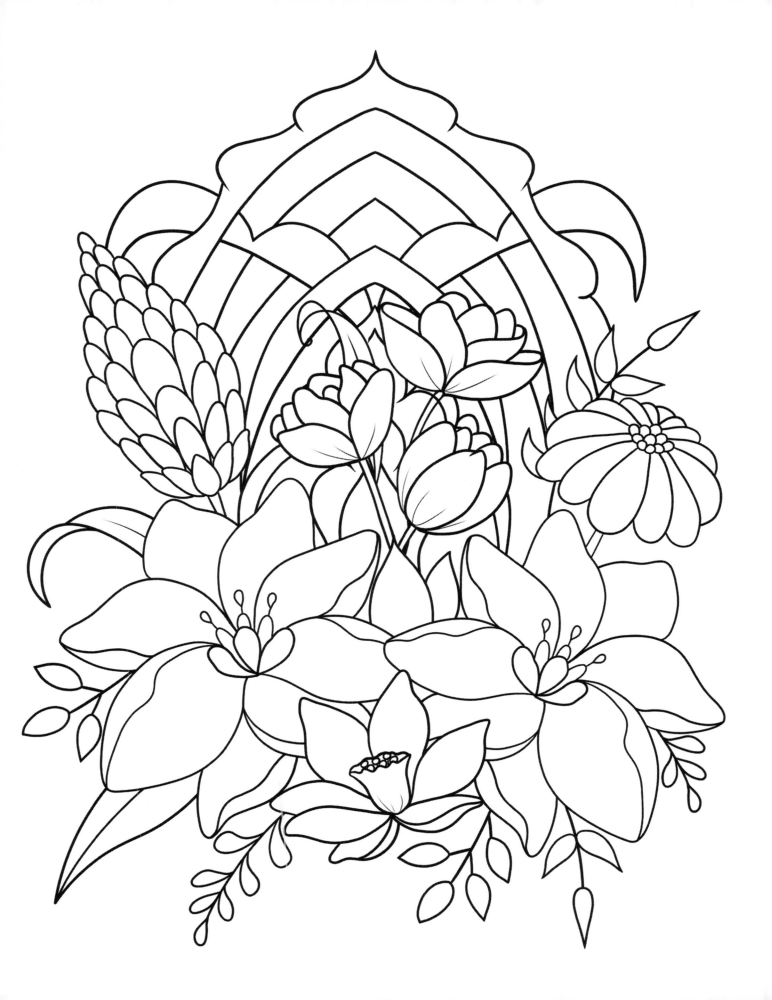

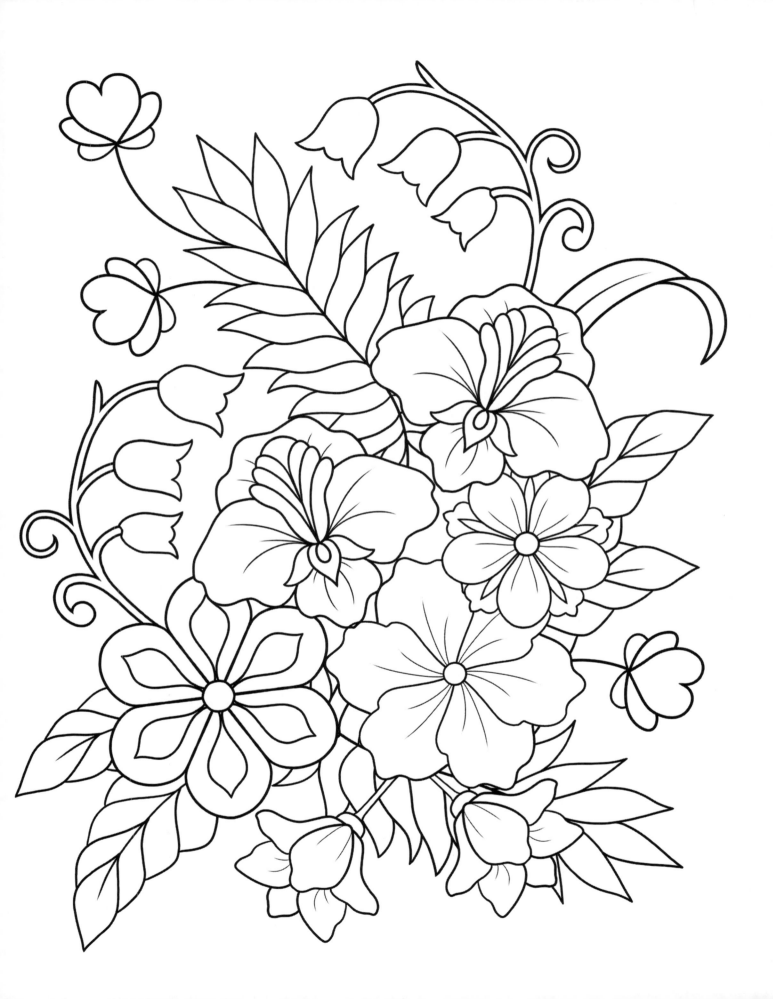

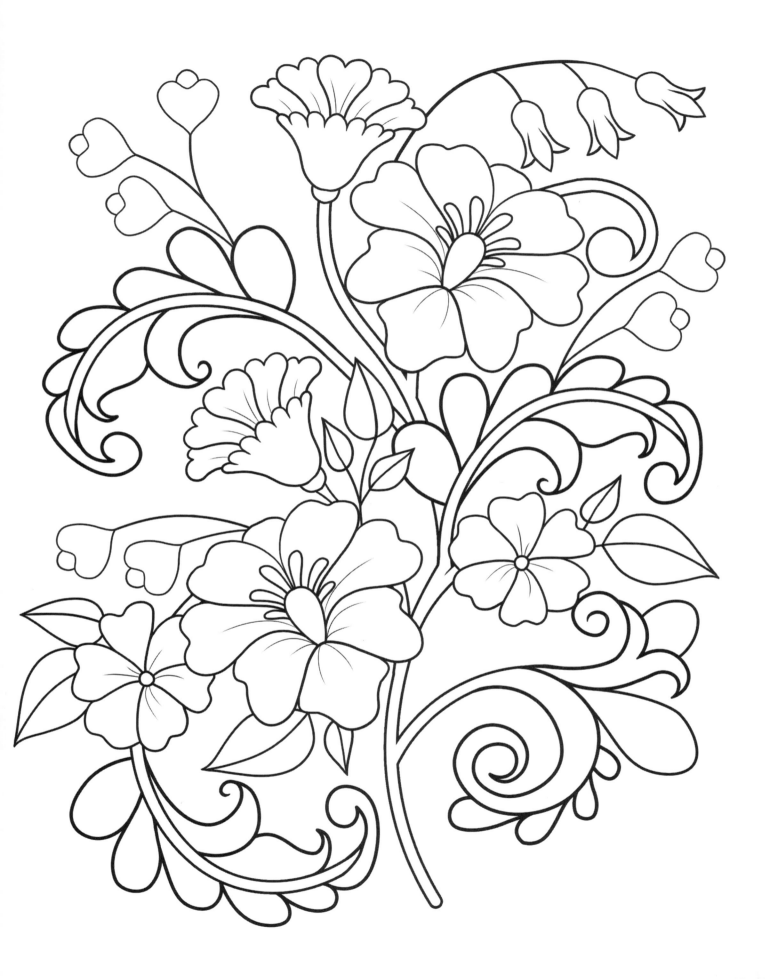

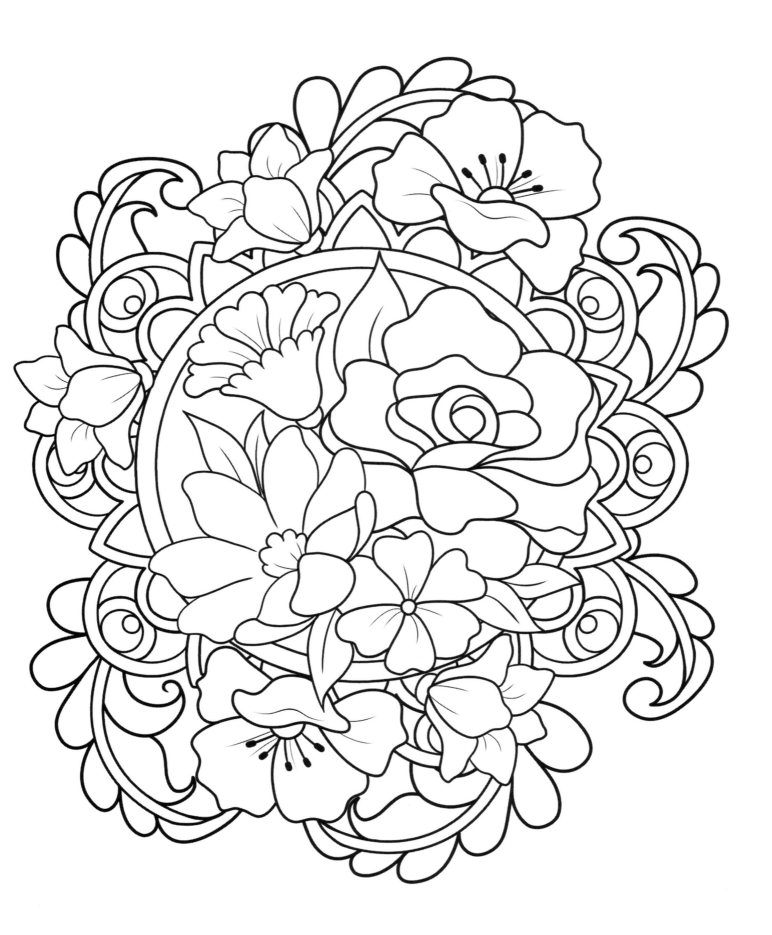

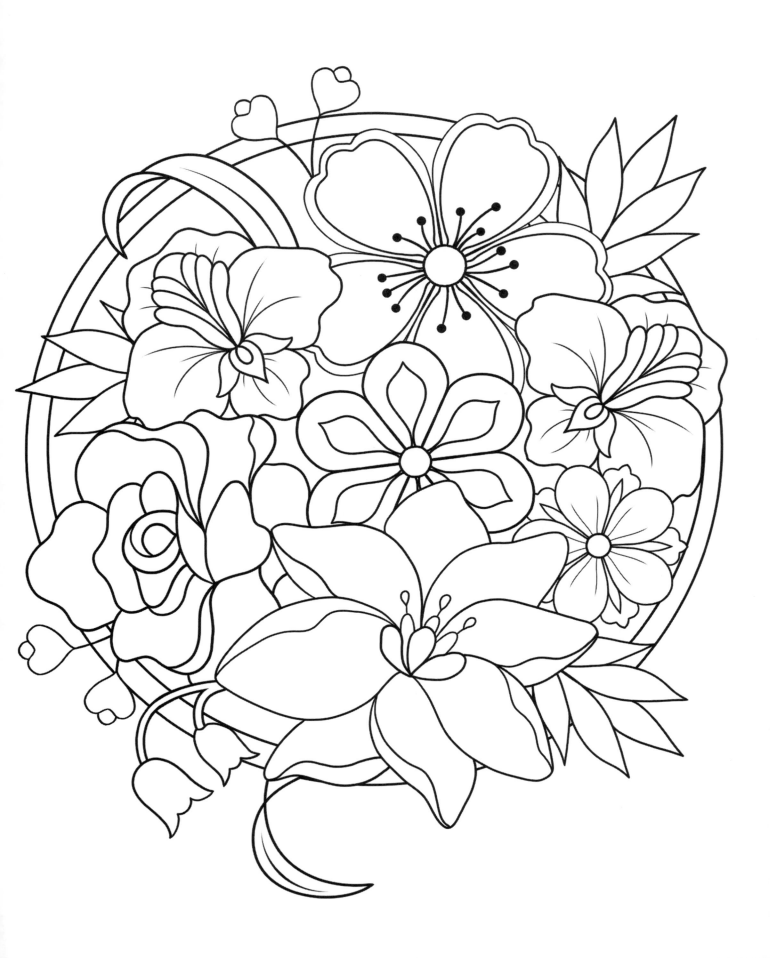

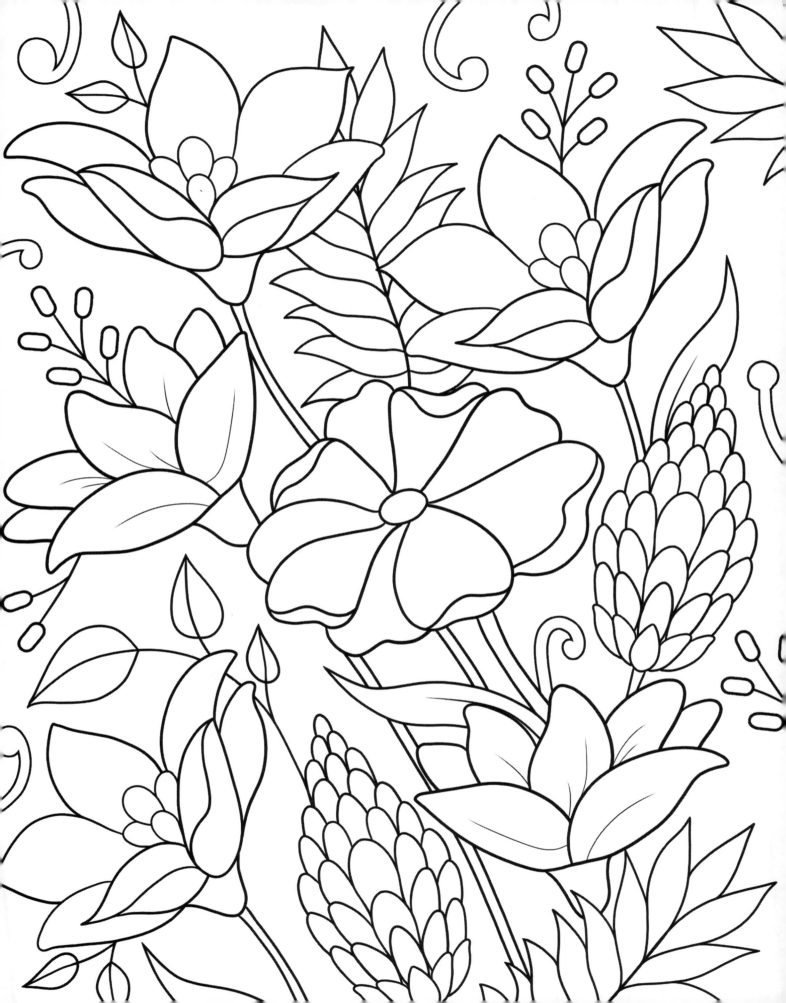

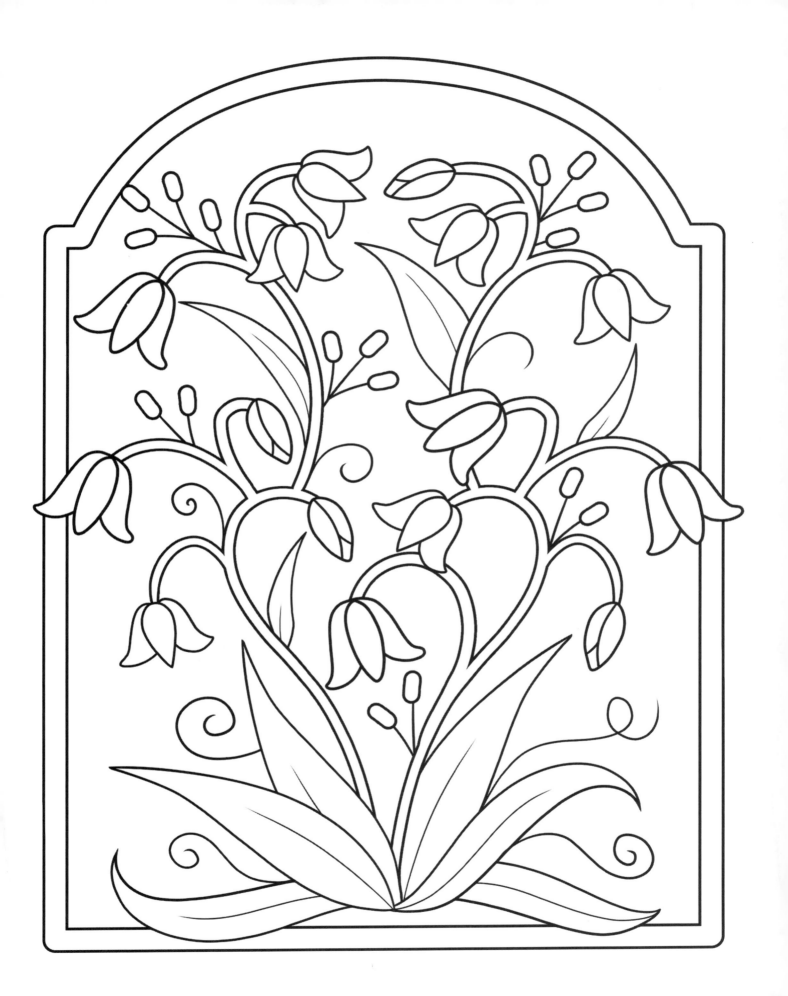

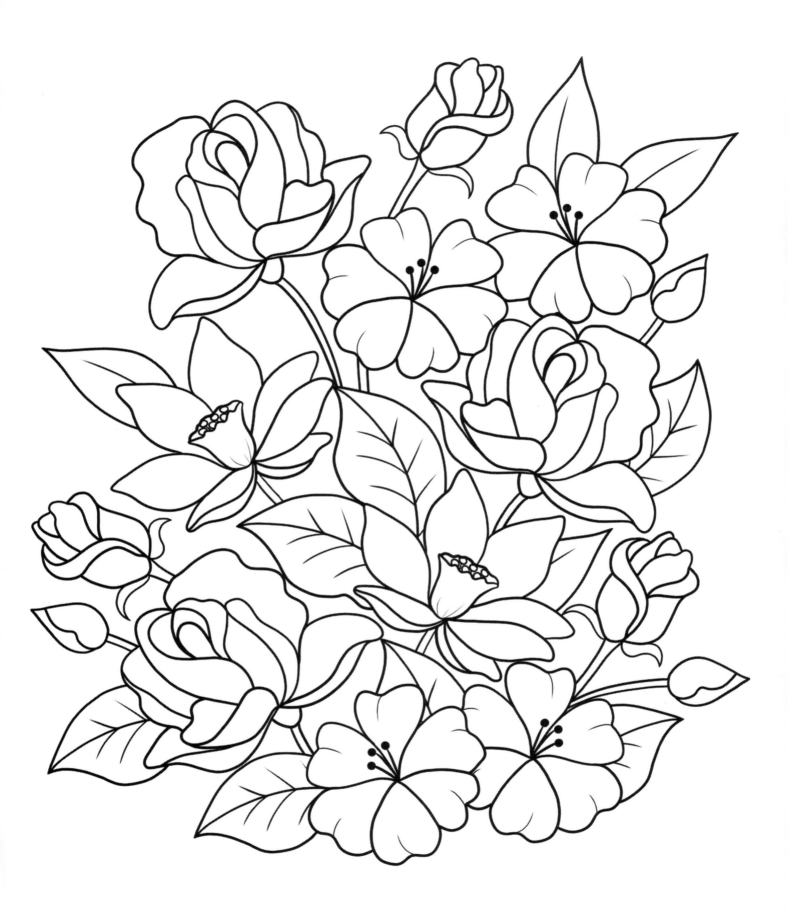

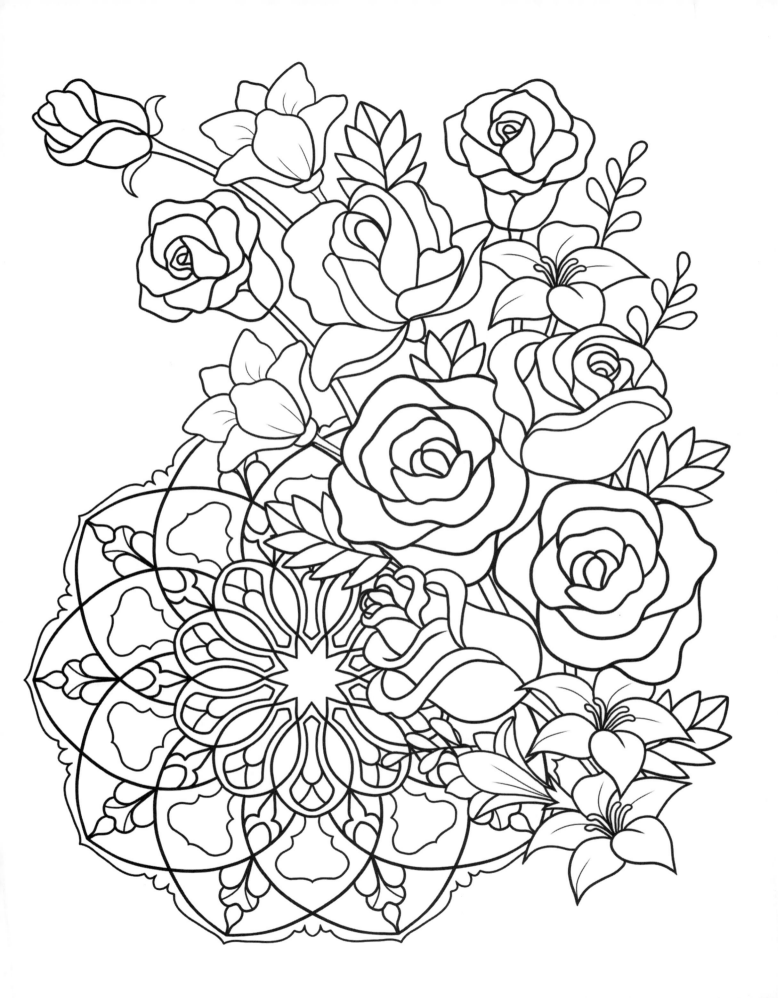

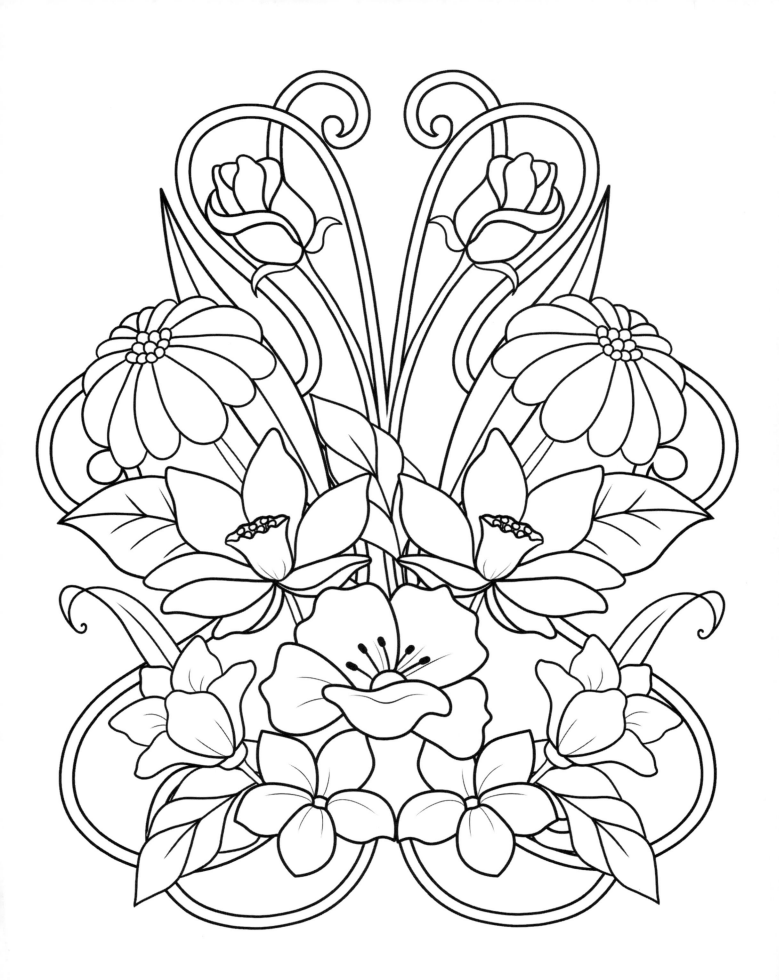

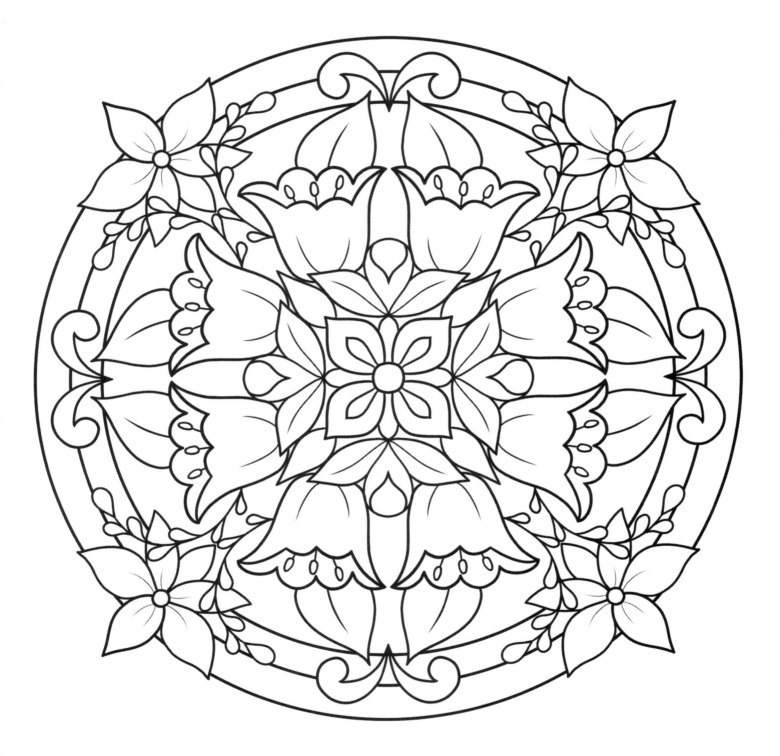

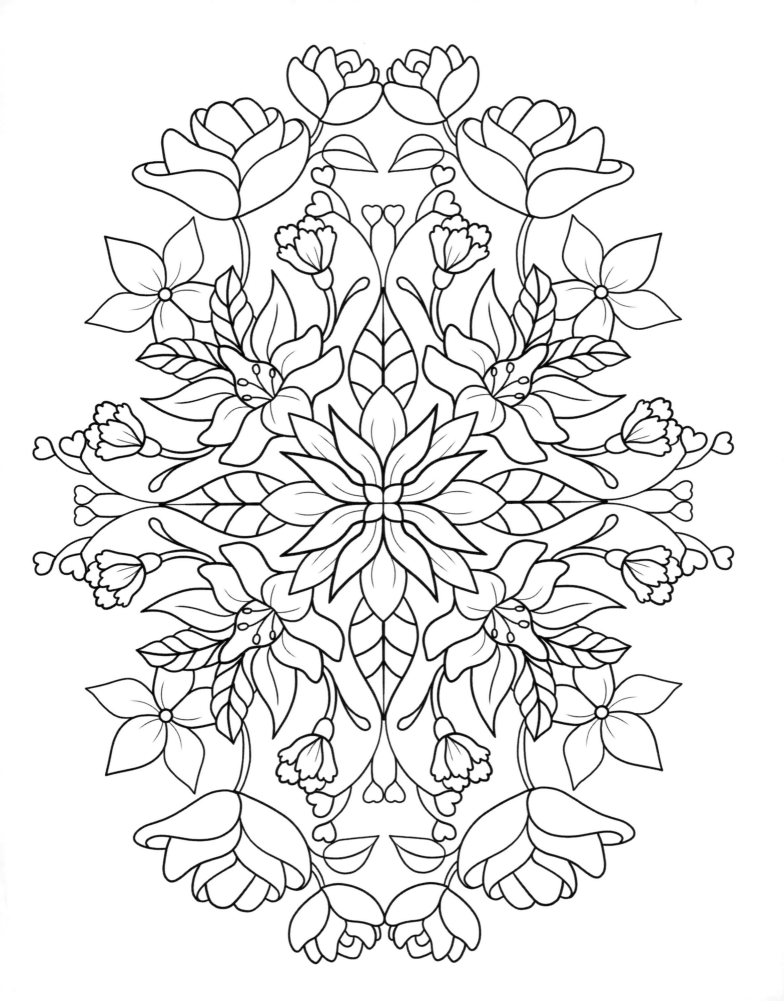